MAINE

IMPRESSIONS

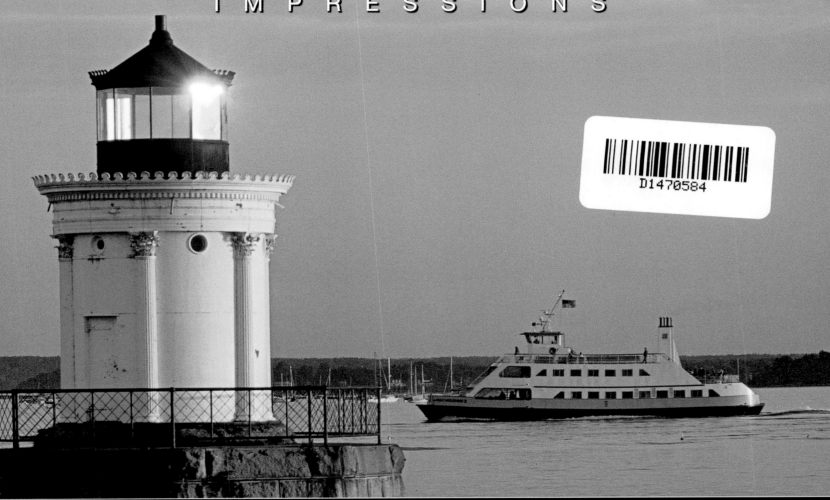

PHOTOGRAPHY BY NANCE TRUEWORTHY

FARCOUNTRY PRESS

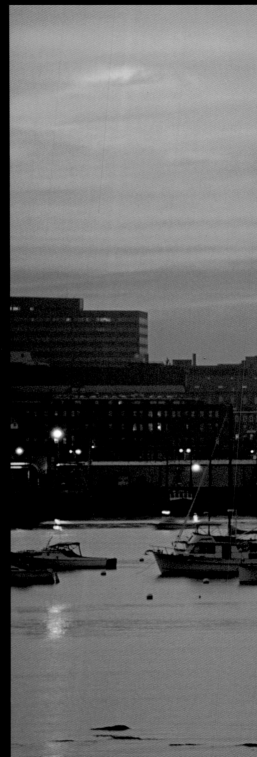

Right: One-fourth of Mainers live in and around Portland, the state's largest city (with 230,000 metro-area residents) and its economic capital. This sunset view from South Portland shows the city-center skyline.

Title page: The Casco Bay Ferry passes Portland Breakwater Lighthouse, built in 1875 and fondly referred to by locals as the Bug Light because of its small size.

Front cover: The Portland Head Light, Cape Elizabeth, is thought to be the most photographed lighthouse in the United States.

Back cover: A couple explores Higgins Beach, Scarborough, on a golden evening.

ISBN 10: 1-56037-414-4
ISBN 13: 978-1-56037-414-5

© 2007 by Farcountry Press
Photography © 2007 by Nance Trueworthy

For more information about our books, write Farcountry Press, P.O. Box 5630, Helena, MT 59604; call (800) 821-3874; or visit www.farcountrypress.com.

Created, produced, and designed in the United States.
Printed in China.

12 11 10 09 08 07 1 2 3 4 5 6

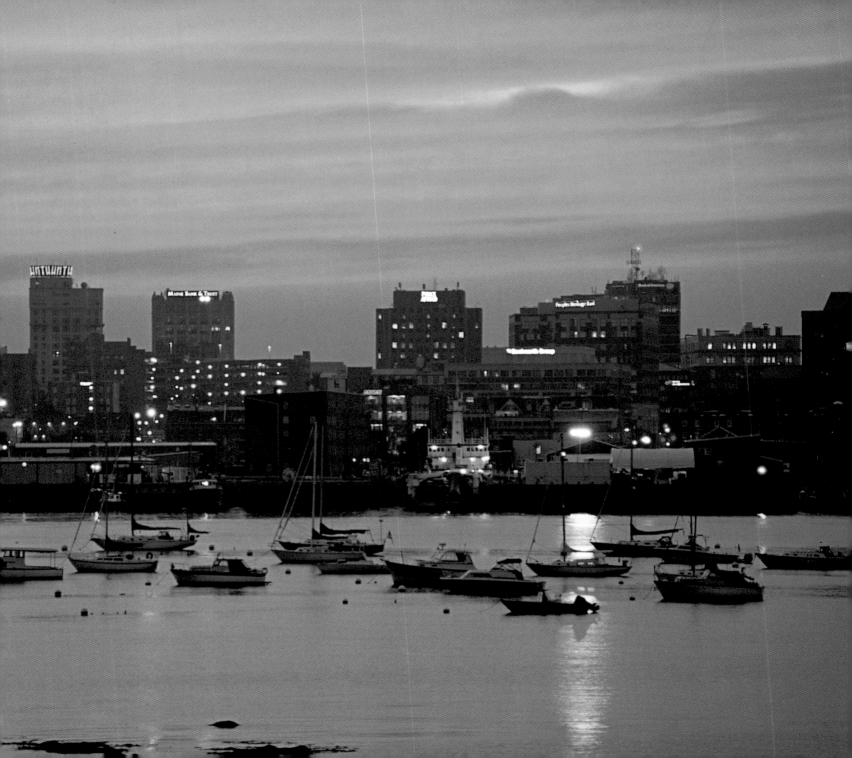

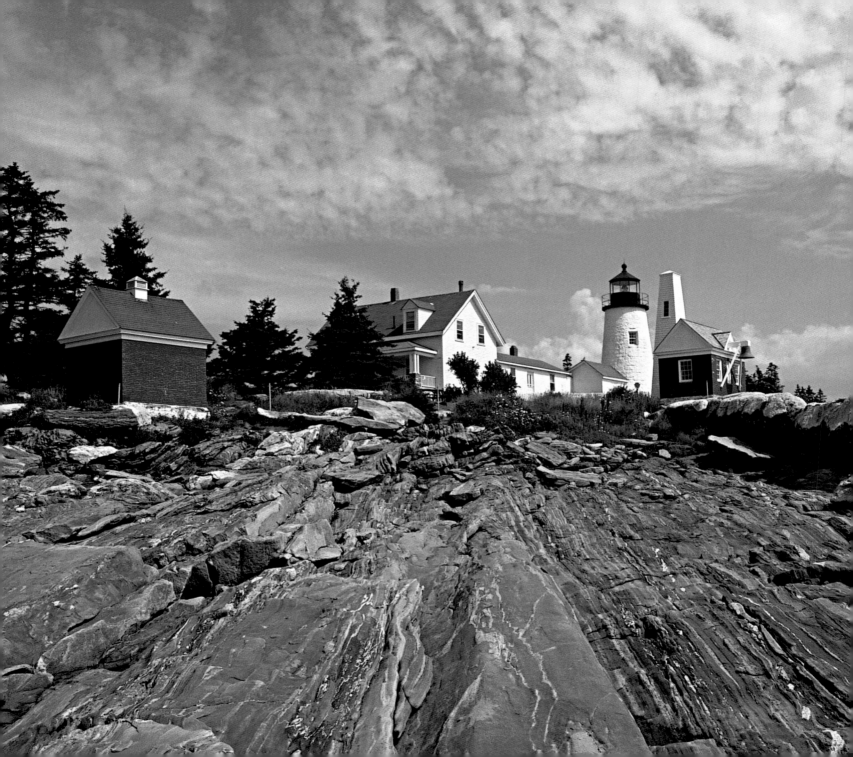

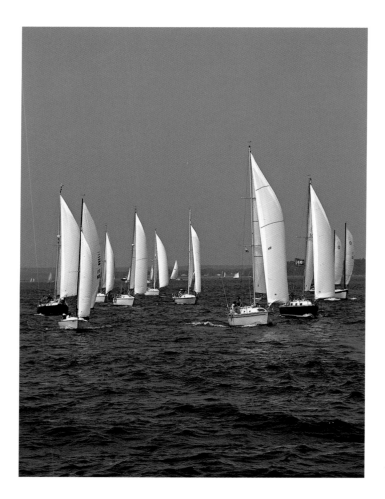

Above: June through early September is sailboat regatta season on Casco Bay.

Left: Pemaquid Point's rough, rocky coastline has threatened and claimed many ships throughout the centuries. The first Pemaquid Point Lighthouse was erected in 1827 but was replaced with a double-walled tower only eight years later. Today, the lightkeeper's home is a museum.

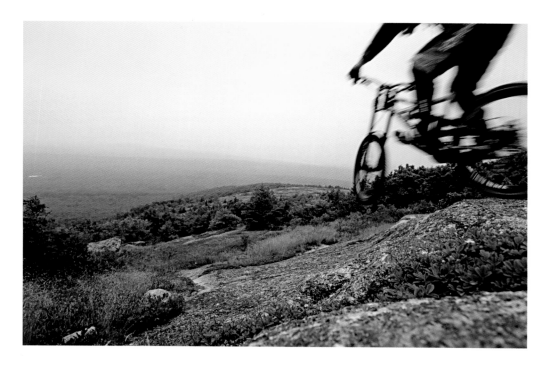

Above: Approximately fifteen miles south of Bangor, launch your bike from Mount Waldo's granite, which was quarried to build Maine's Fort Knox. Erosion has exposed the granite, which extends four miles below the Earth's surface.
PHOTO BY CHRIS MILLIMAN / AURORA PHOTOS

Right: In central Maine's Baxter State Park, Howe Brook Trail leads hikers six miles past gentle falls and reflecting pools along the river valley.
PHOTO BY GERRI GAUTHIER

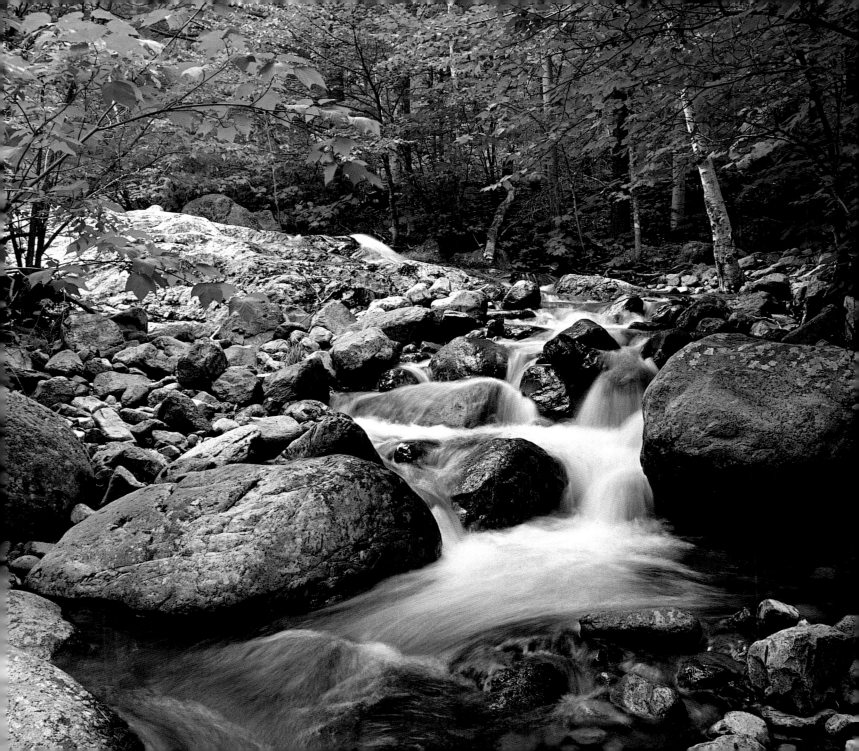

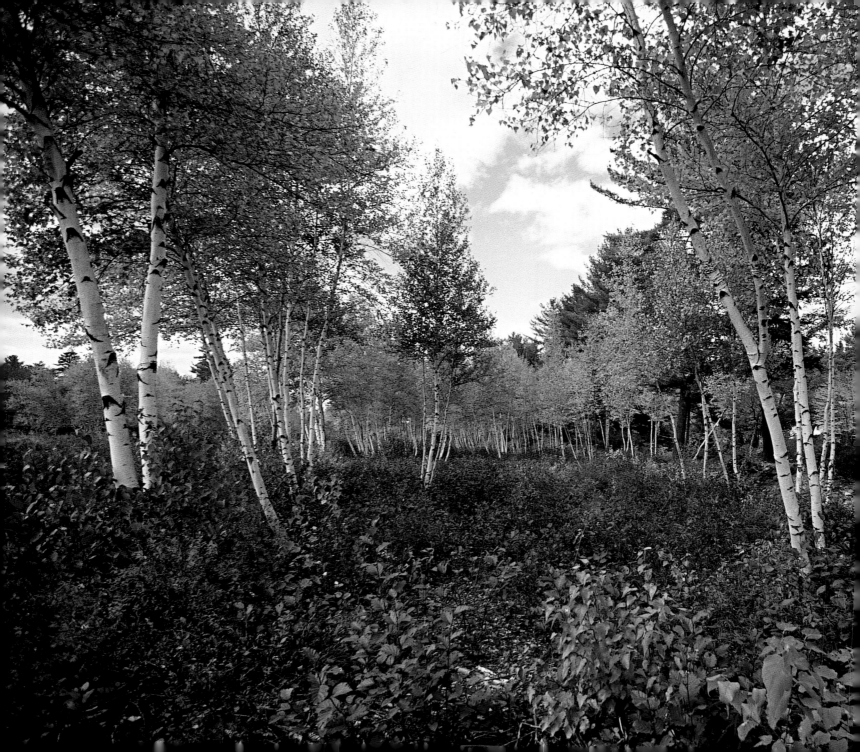

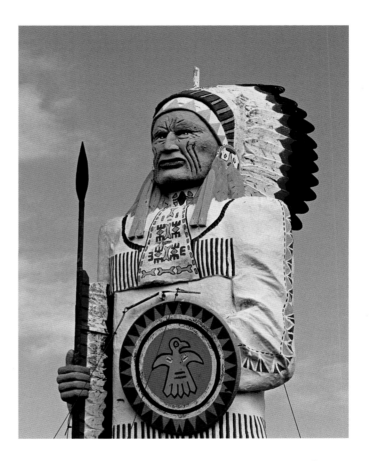

Above: Freeport's twenty-five-foot-tall "Big Indian" caused traffic jams in the 1960s when it was transported from New Jersey to a now-closed souvenir shop. The statue itself has survived as a folk-art landmark.

Left: White birch trees add their golden hue to the autumn woods near Bethel.

Right: Portland, site of this wintry scene in Deering Oaks Park, receives seventy inches of snow each year.

Below: Tree-lined and snow-covered, this road in southern Maine leads from Kennebunk to Parson's Beach, privately owned land where visitors are welcome to stroll the seashore.

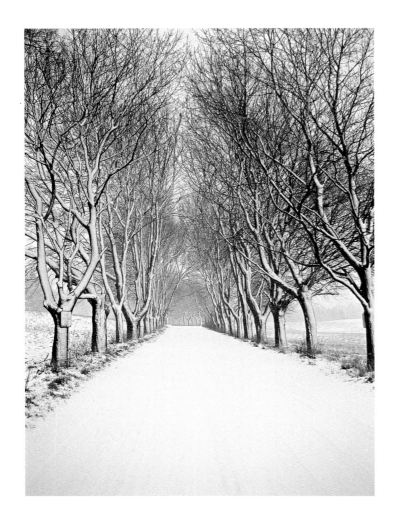

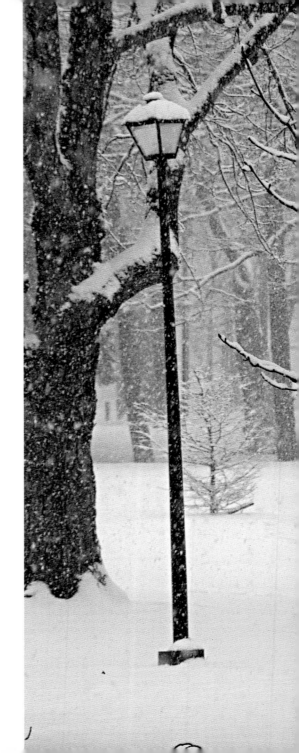

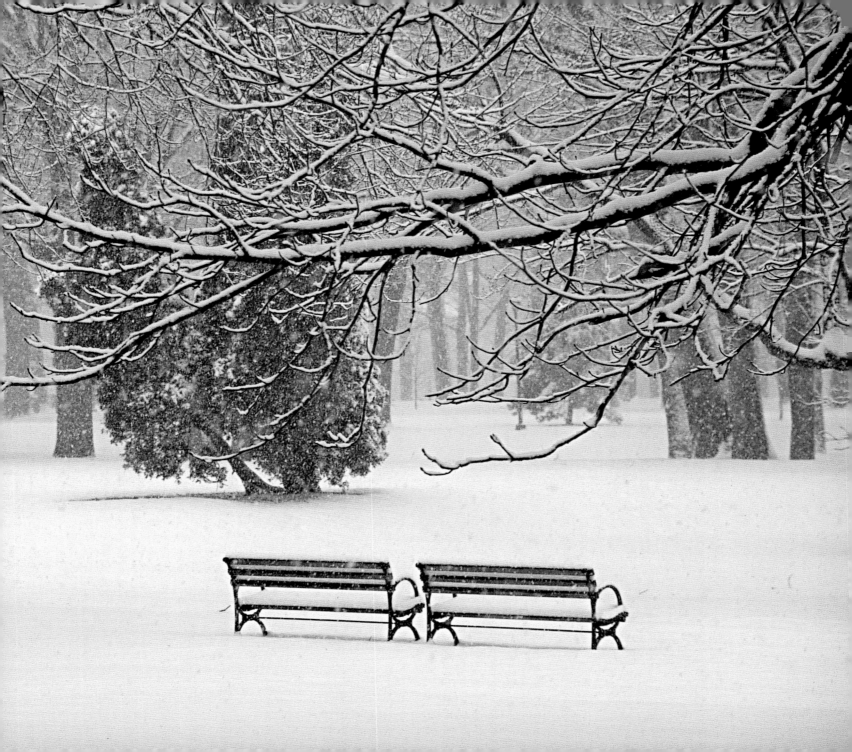

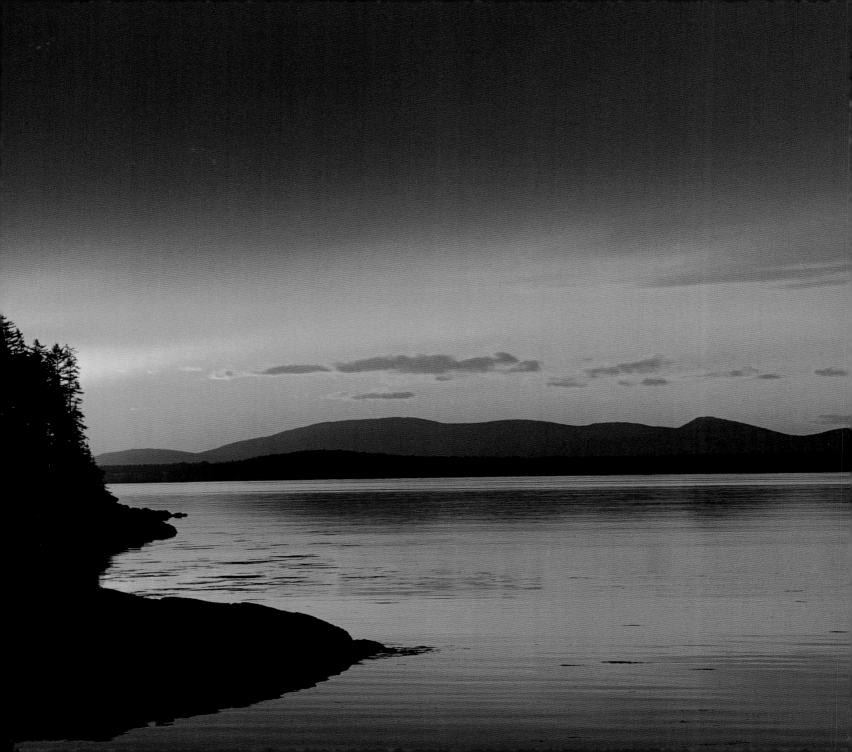

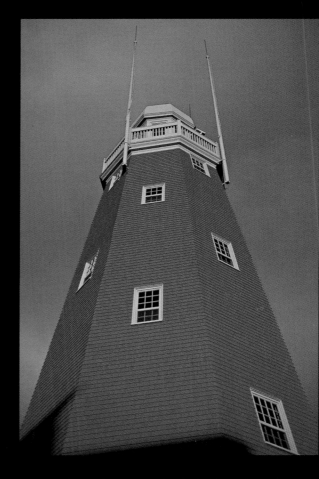

Above: Built in 1807 at Portland's harbor, the eighty-six-foot-tall Portland Observatory Maritime Signal Tower allowed arriving ships' captains to communicate with land before docking. By "signalizing," they reserved wharf berths and hired stevedore crews while still at sea. Portland's is the last surviving signal tower in the United States.

Left: In this view from Cape Rosier, a fiery sunset ignites Penobscot Bay and the sky above the Camden Hills, which can be seen in the distance.

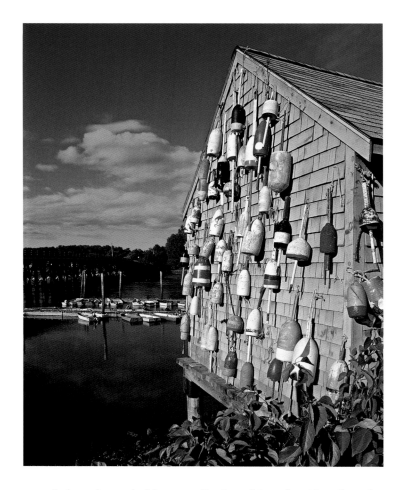

Above: Lobster buoys hold personalized markings that identify each trap's owner. These are exhibited on a lobster shack at York, the first chartered city in the United States, dating from 1641.

Right: Cyclists enjoy the seaside road near the village of Biddeford Pool in southern Maine.

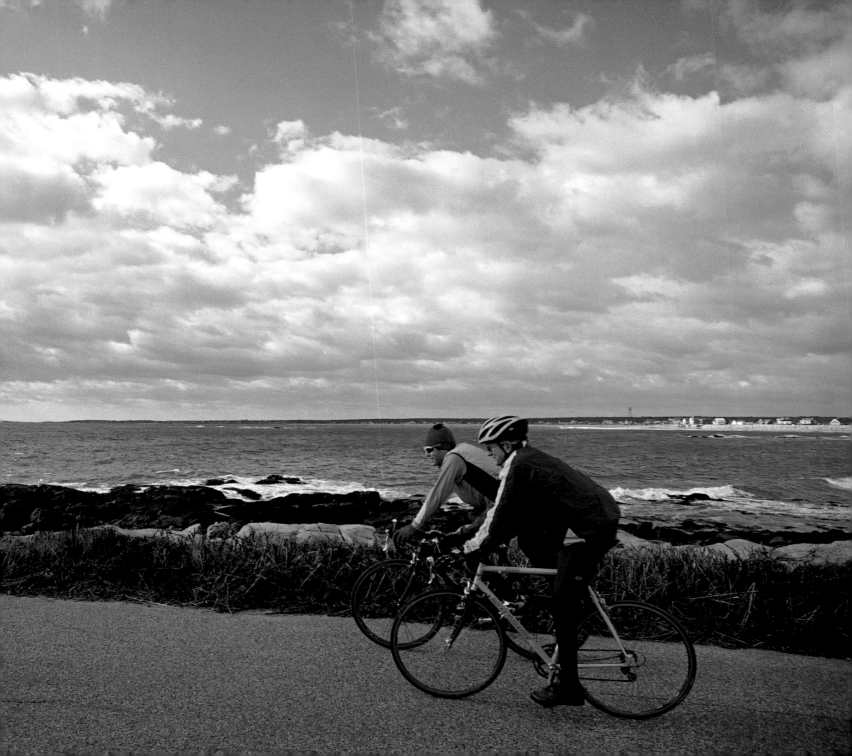

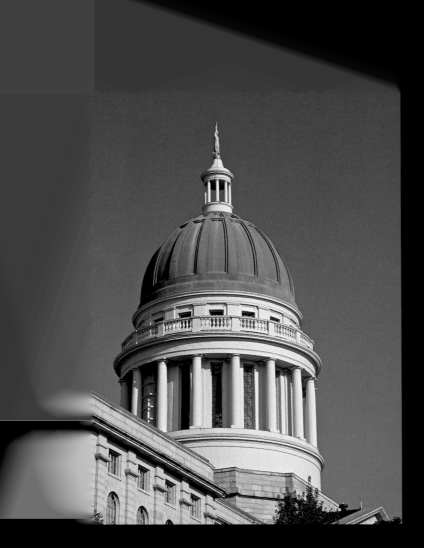

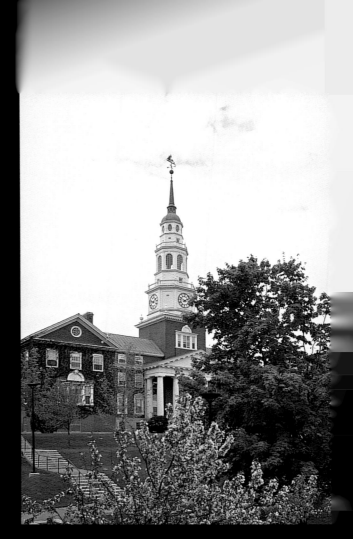

Called the State House, Maine's capitol in Augusta was completed in 1832 and remodeled in 1909–1910. Atop its 150-foot-high copper dome stands the figure of Wisdom, sculpted by W. Clark Noble of Gardiner. Augusta, located between Portland and Bangor, replaced Portland as the capital in 1827, seven years

Colby College opened its doors in Waterville, northeast of Augusta, in 1813 to an all-male student body and began allowing women to attend in 1871. The campus overlooks Waterville from Mayflower Hill.

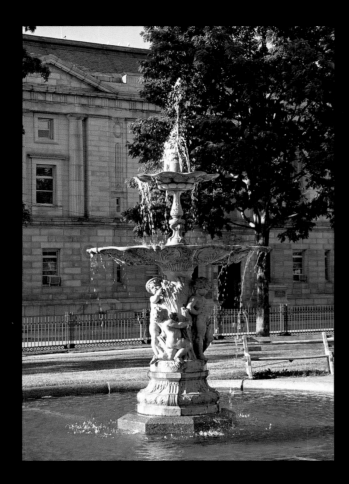

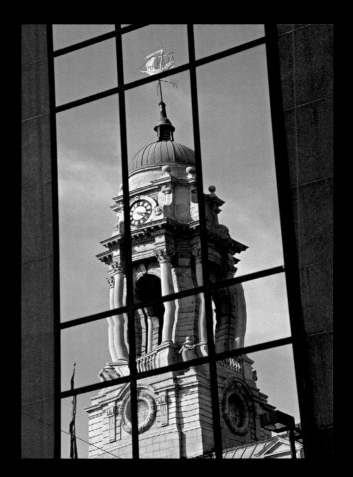

This fountain in Portland's Lincoln Park, next to the Cumberland County Courthouse, produces a chorus of splashing water.

A modern window reflects Portland's City Hall dome, which dates from 1909.

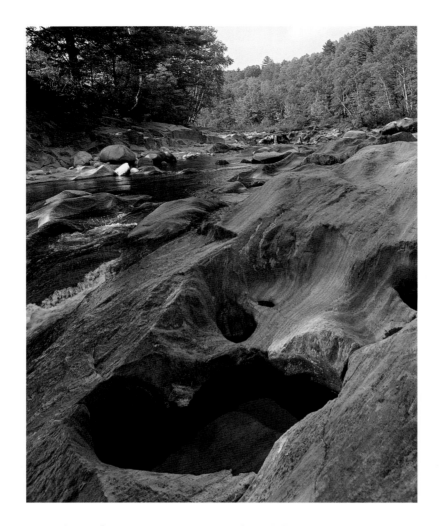

Above: The Swift River cut Coos Canyon through bedrock near Byron in western Maine and is a popular place to pan for gold.

Right: Does life get any better than fly fishing the Royal River in Yarmouth in late afternoon?

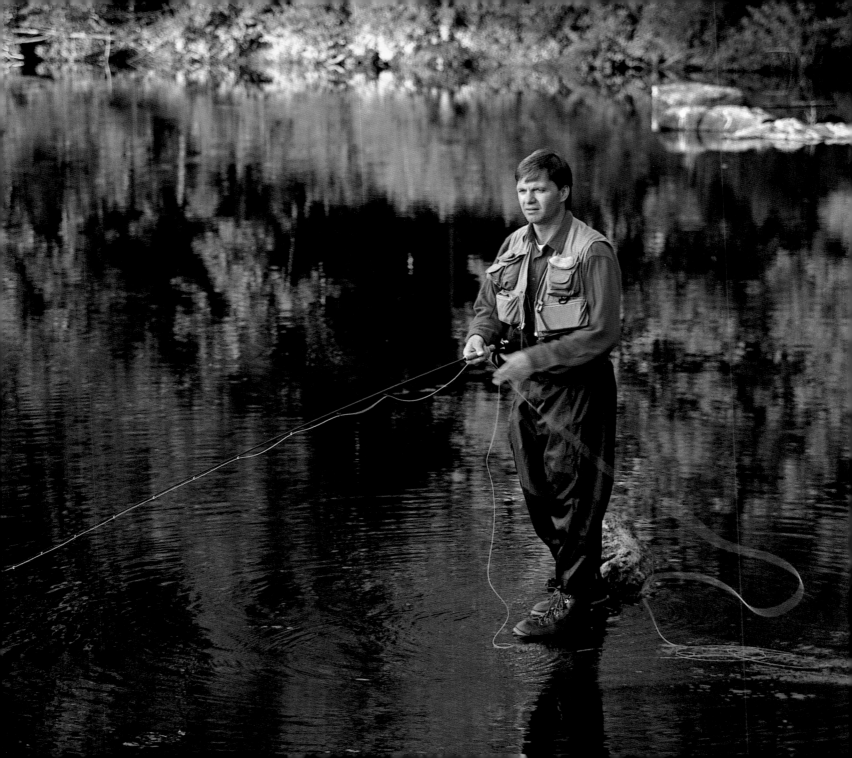

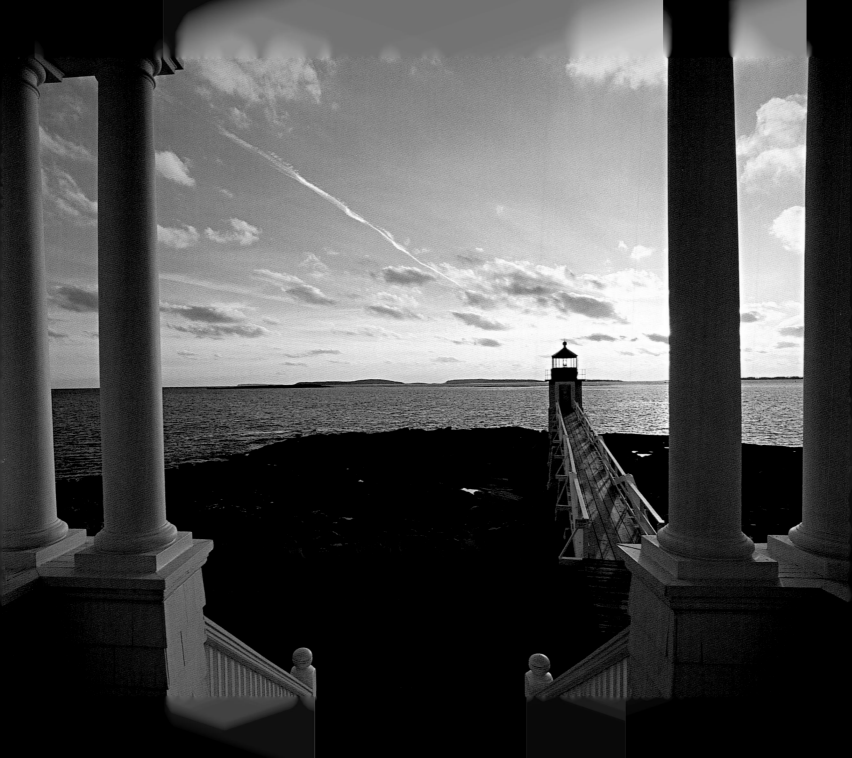

Facing page: Marshall Point Light guides vessels entering Port Clyde Harbor. The granite lighthouse, dating from 1857–1858 and rising thirty-one feet, is not open to the public, but the lighthouse keeper's house is now the Marshall Point Lighthouse Museum.

Below: Located off Park Loop Road in Acadia National Park, Sand Beach is nestled in an inlet on the east side of Mount Desert Island.

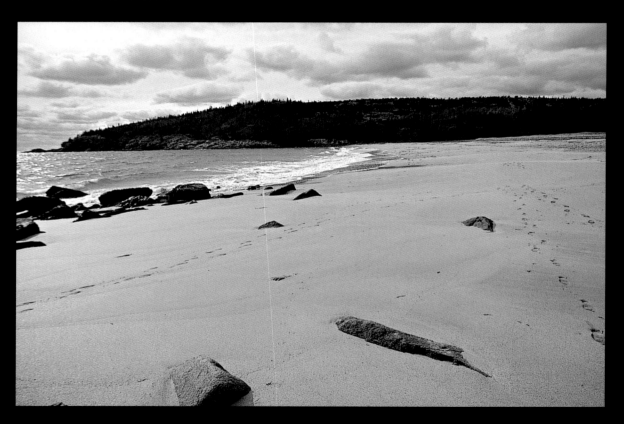

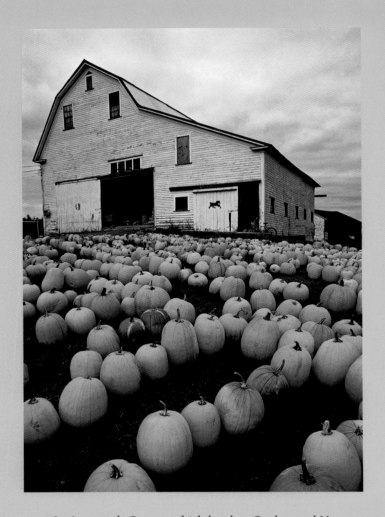

Above: In Aroostook County, which borders Quebec and New Brunswick, the pumpkin harvest accumulates outside a Presque Isle barn.

Right: Autumn's shades tint the forest in central Maine near Millinocket along the 350-mile Penobscot River.

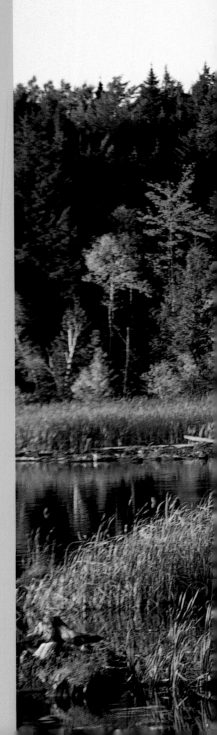

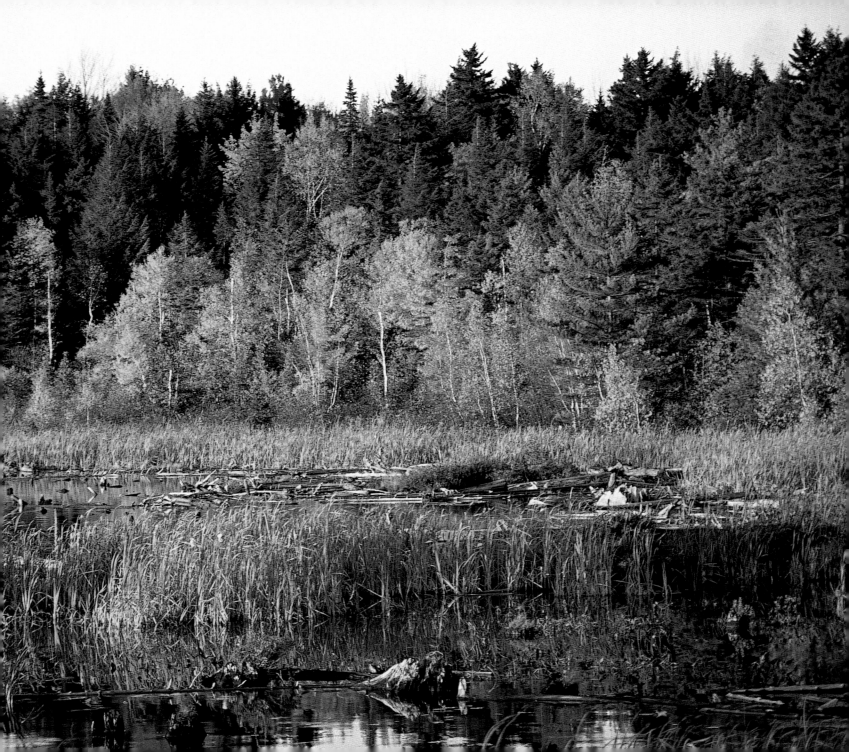

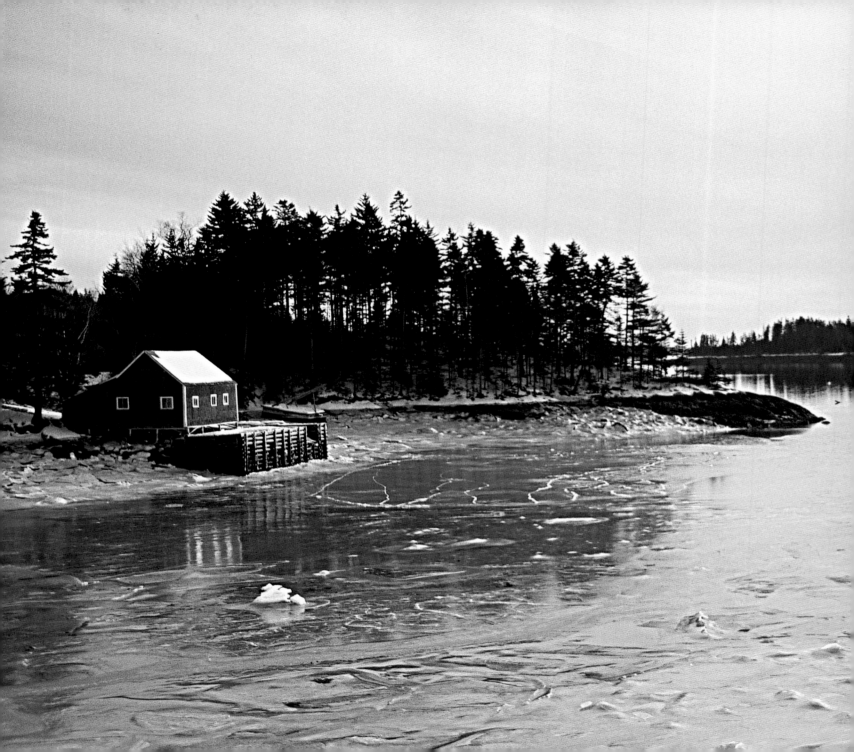

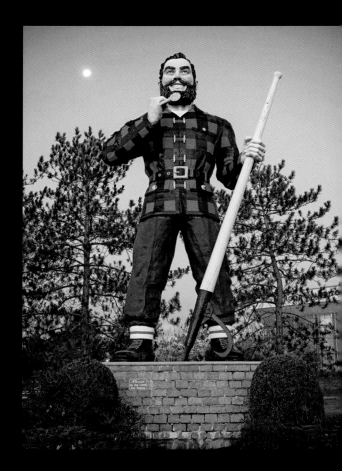

Above: The legendary lumberjack Paul Bunyan, an ax in his right hand and a cant hook in his left, has stood thirty-one-feet tall above his pedestal at Bangor since 1959, supporting the city's claim as his birthplace (even though residents of Akeley, Minnesota, site of another Bunyan statue, politely disagree).
PHOTO BY CARL D. WALSH / AURORA PHOTOS

Left: Near Bucks Harbor, the frozen edges of Machias Bay indicate that winter is tightening its grip on the Atlantic Ocean.

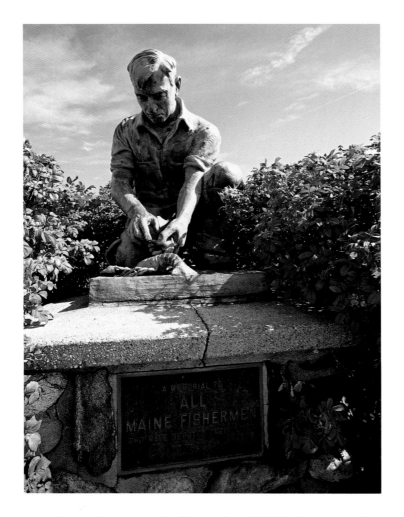

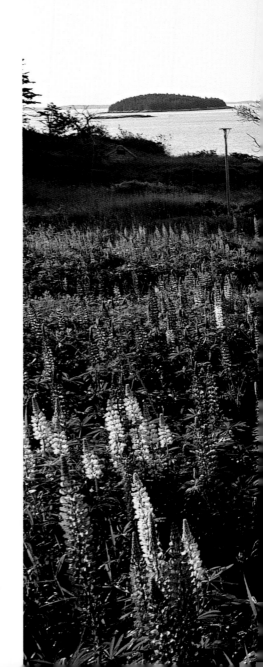

Above: For the Maine State Pavilion at the 1939 World's Fair, sculptor Victor Kahill created the *Maine Lobsterman*, a statue of Elroy Johnson of Bailey Island, in tribute to all Maine fishermen. Today, three castings of the statue are on public display: this one at Bailey Island, another in Portland, and one that was placed in Washington, D.C., in 1983 by the Cundys Harbor Campfire Girls.

Right: At Stonington on Deer Isle in downeast Maine, lupine blossoms adorn a harborside field. The fishing village long has attracted artists, crafters, antiquers, book collectors, and vacationers.

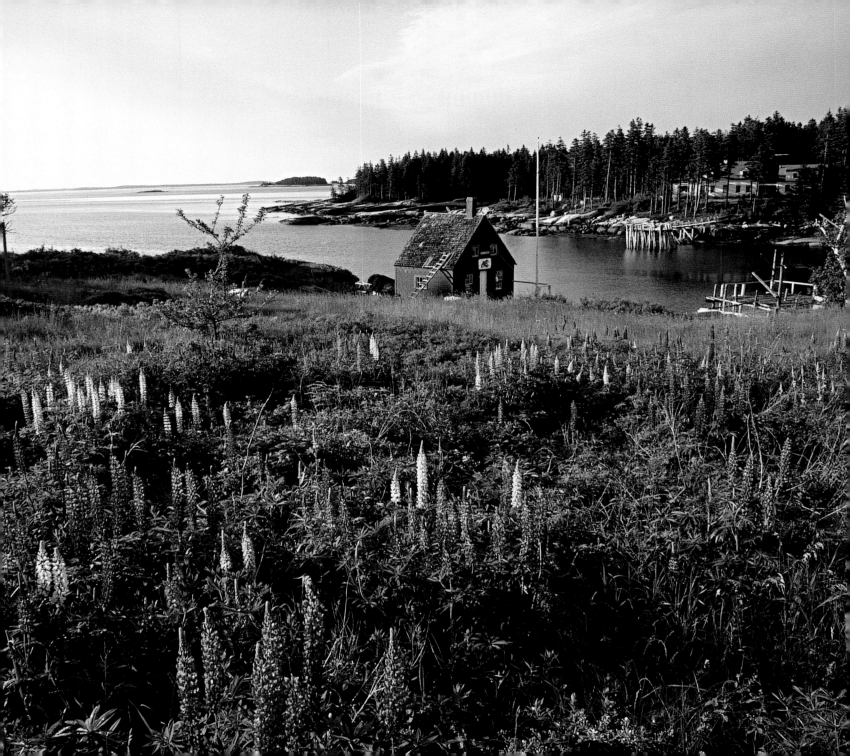

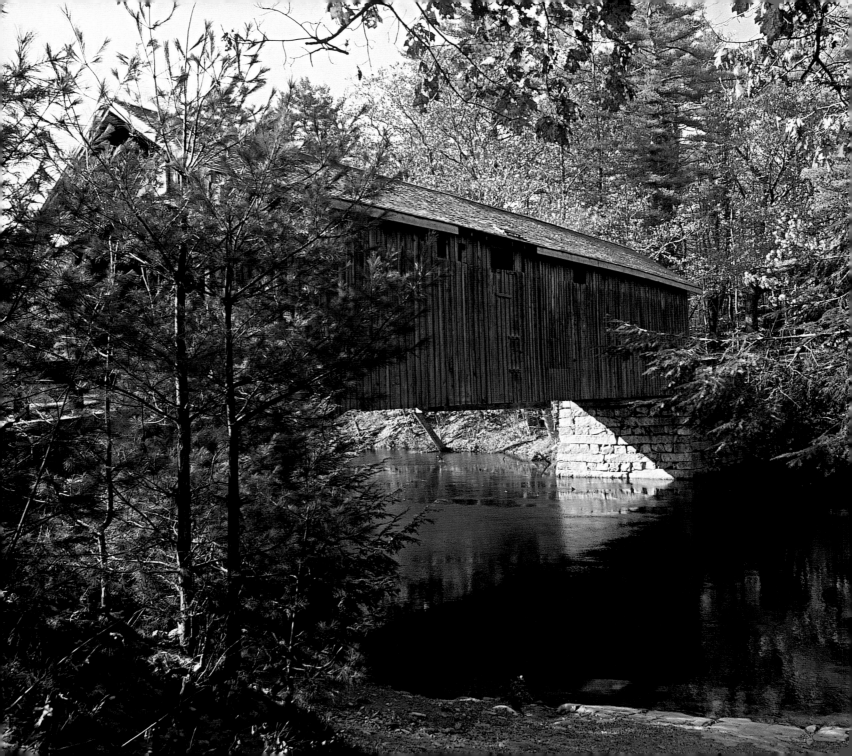

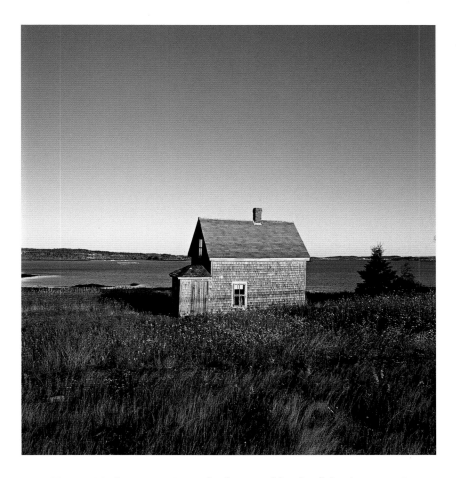

Above: Here at Machias every June, the first naval battle of the American Revolution is celebrated. On June 12, 1775, the private sloop *Unity* attacked the British armed vessel *Margaretta* and captured it within an hour. The *Margaretta's* guns were moved to the *Unity* and used by colonists from then on.

Left: Dating from 1864, Babb's Bridge over the Presumpscot River in South Windham was Maine's oldest covered bridge until vandals burned it down in 1973. This reconstruction has stood since 1976.

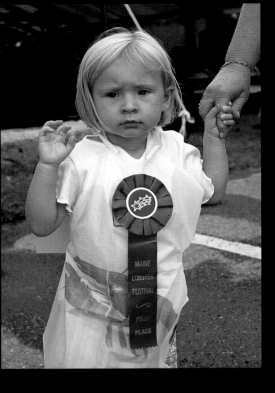

Left: Contests are part of the fun for children and adults at the Maine Lobster Festival, held at Rockland in early August. This reluctant heroine has just been named "world's smallest sardine packer."

Below: A Maine Lobster Festival volunteer readies cooked lobsters for the hungry crowd, who will eat twelve tons of the creatures, along with shrimp, clams, mussels, and other seafood.

Right: Caring for their trawler and gear is ongoing work for these Port Clyde fishermen.

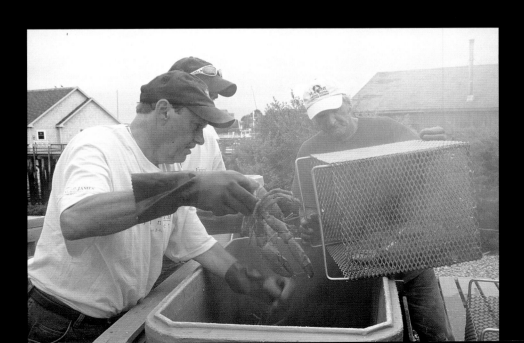

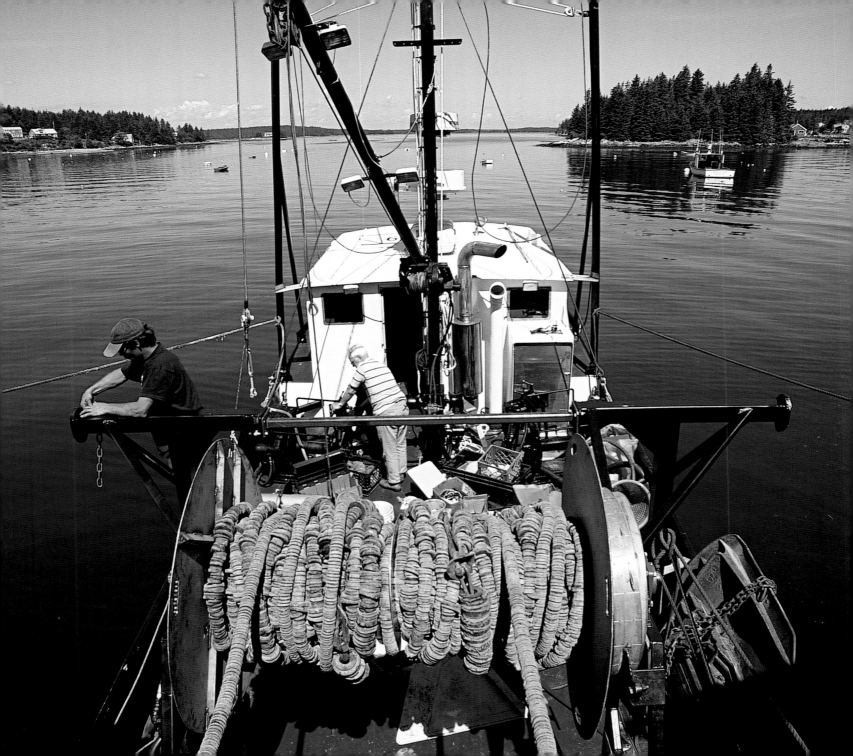

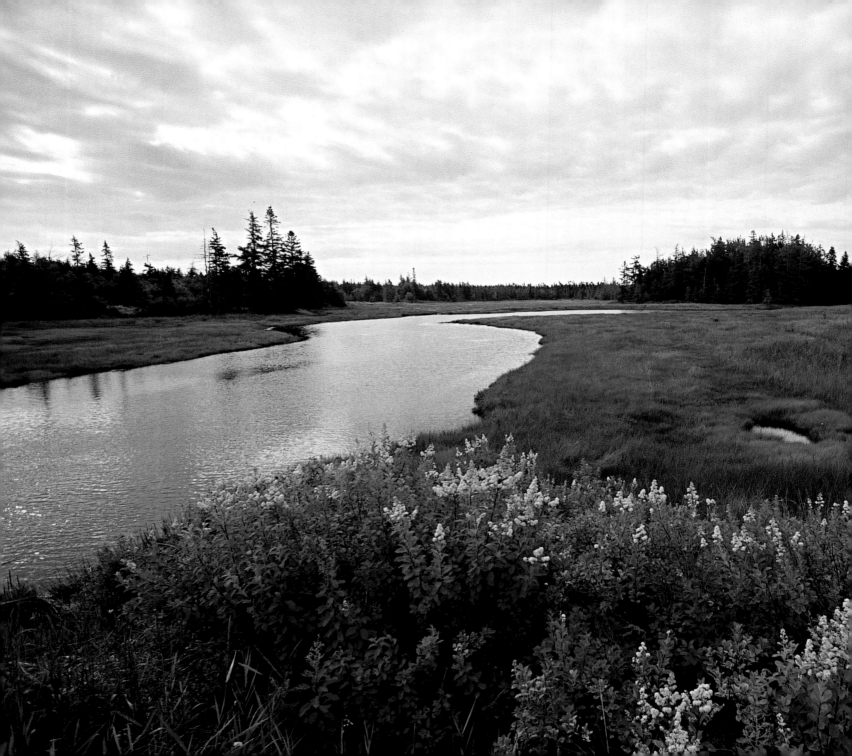

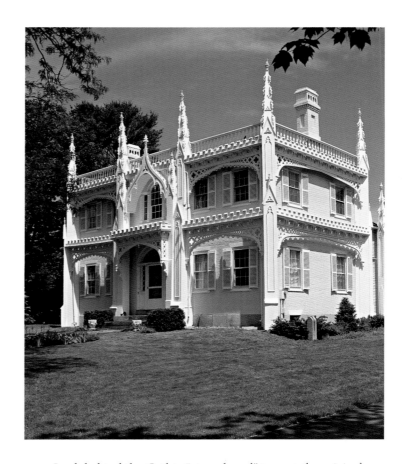

Above: Look behind the Gothic "gingerbread" to spot the original, plain, Federal-style home built in 1826. After an 1852 fire, the owner added the external touches that give the name "Wedding Cake House" to this Kennebunk structure.

Left: Bass Harbor's tidal marsh provides essential habitat for shorebirds and wading birds, and for migrating ducks and other species, along with fish and shellfish. Maine's marshlands account for less than one percent of its total acreage.

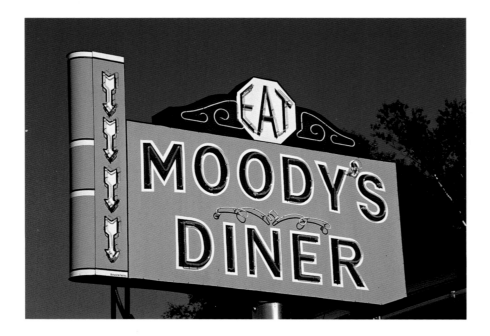

Above: P. B. Moody opened his diner at Waldoboro on Route 1 in 1934, with culinary specialties including blueberry muffins and walnut pie. Today the restaurant seats 104 and is still family run.

Right: The primary occupations in Cape Porpoise are lobstering and fishing.

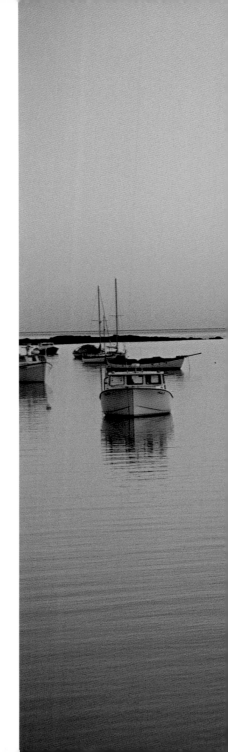

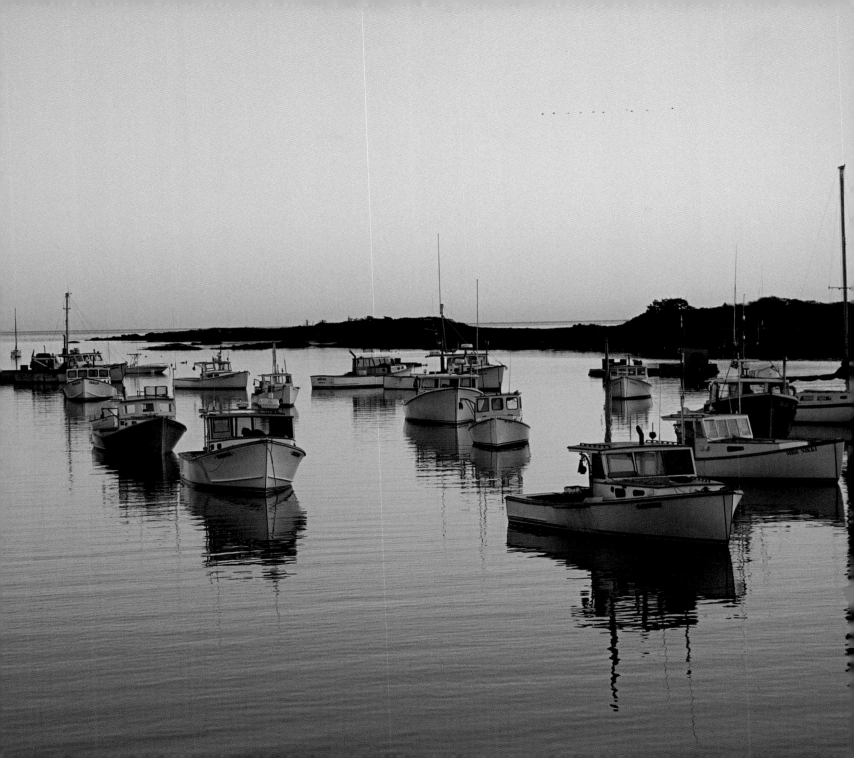

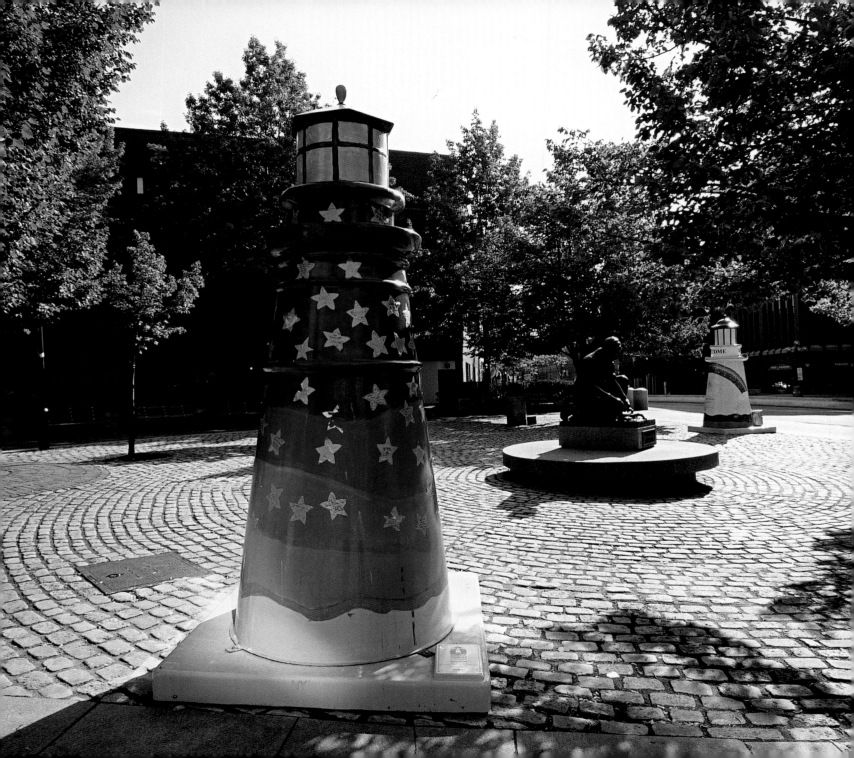

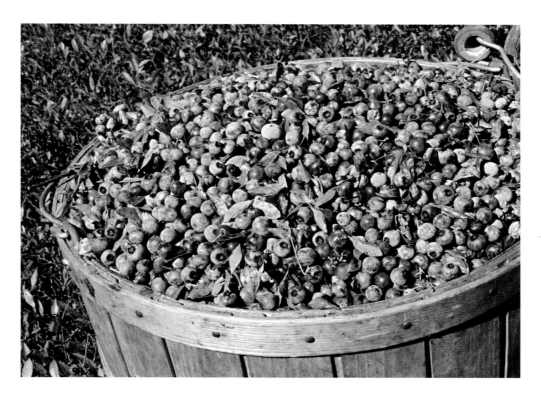

Above: Maine ranks first among the fifty states in producing blueberries, with 60,000 acres offering about 75 million pounds of the tart treats per year.

Left: Lobsterman Plaza in Portland is the home of whimsically painted lighthouses flanking its copy of the *Maine Lobsterman* sculpture.

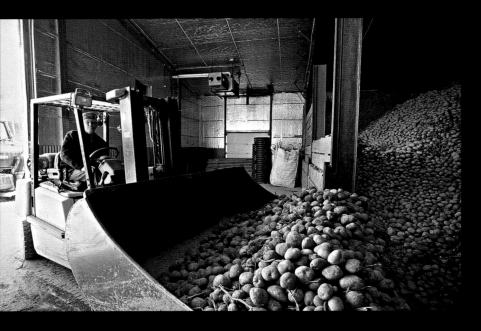

Maine's soil and climate conditions are ideal for potato growing, an industry that began in 1750. The harvest is underway at Green Thumb Farm in Fryeburg *(right)*. After harvest, potatoes are stored in large, cool buildings *(above)*.

Following pages: Coffee Pond near Raymond, northwest of Portland, is but one of the Pine Tree State's 6,000 lakes and ponds. One mile long and a quarter-mile wide, the lake extends to seventy feet in depth.

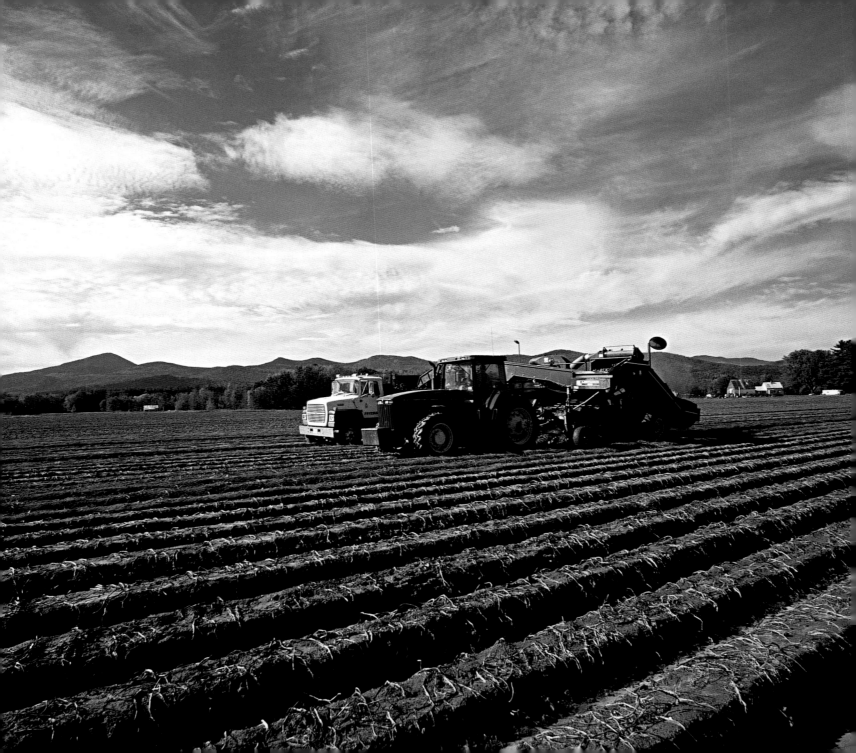

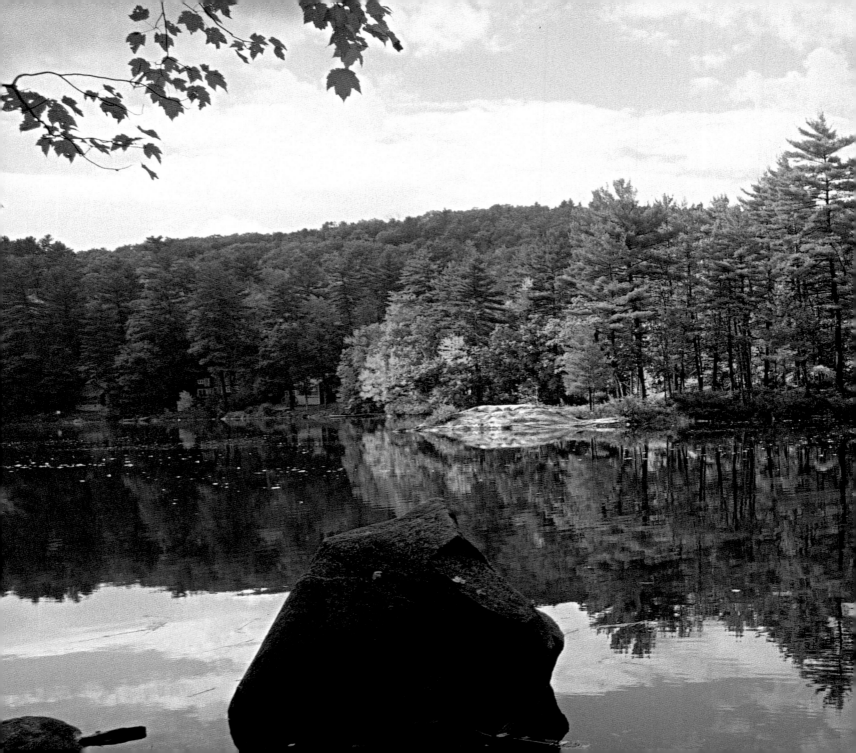

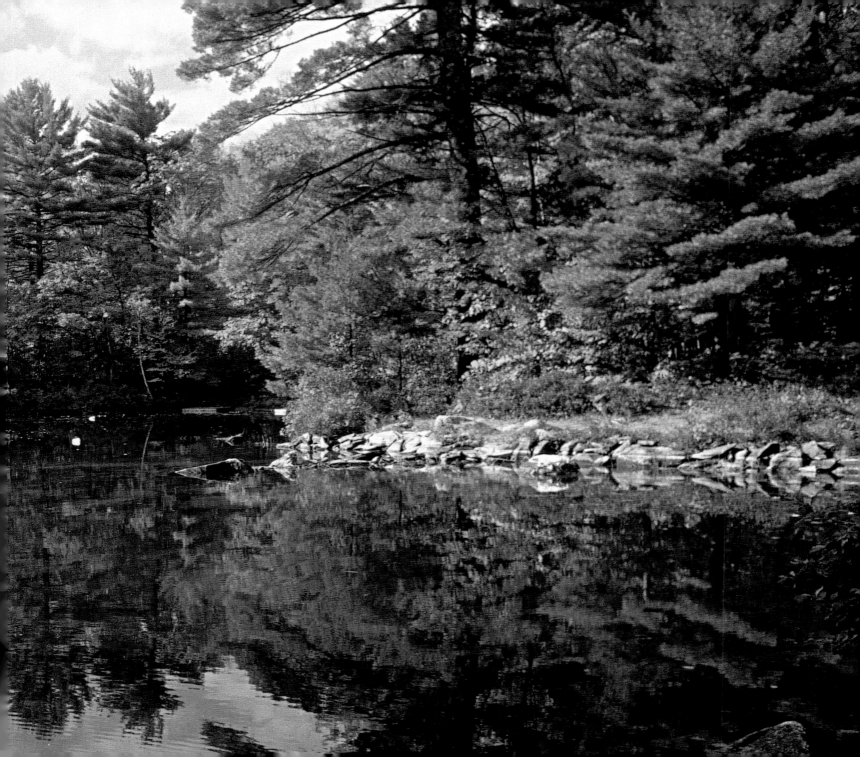

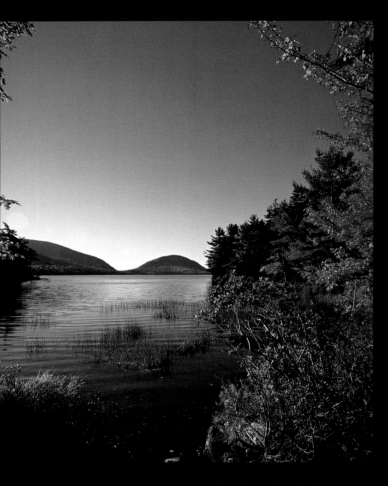

Above: Twenty percent of Acadia National Park is classified as wetland and provides important habitat, such as this lake and its shore, for nesting and migrating birds.

Right: Partway up 1,530-foot Cadillac Mountain in Acadia National Park is this tranquil view of autumn foliage and the Atlantic.

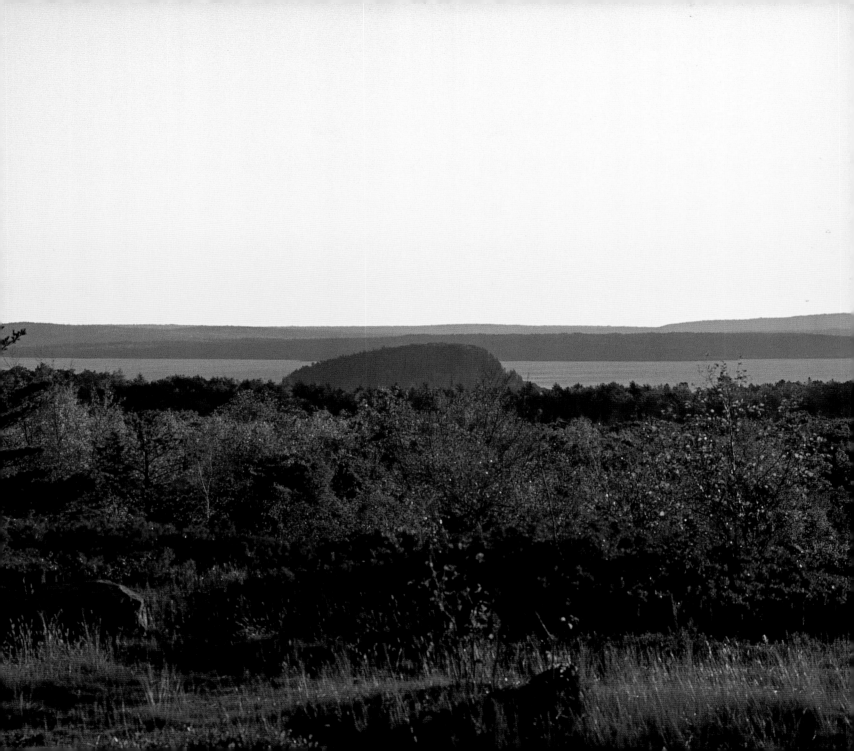

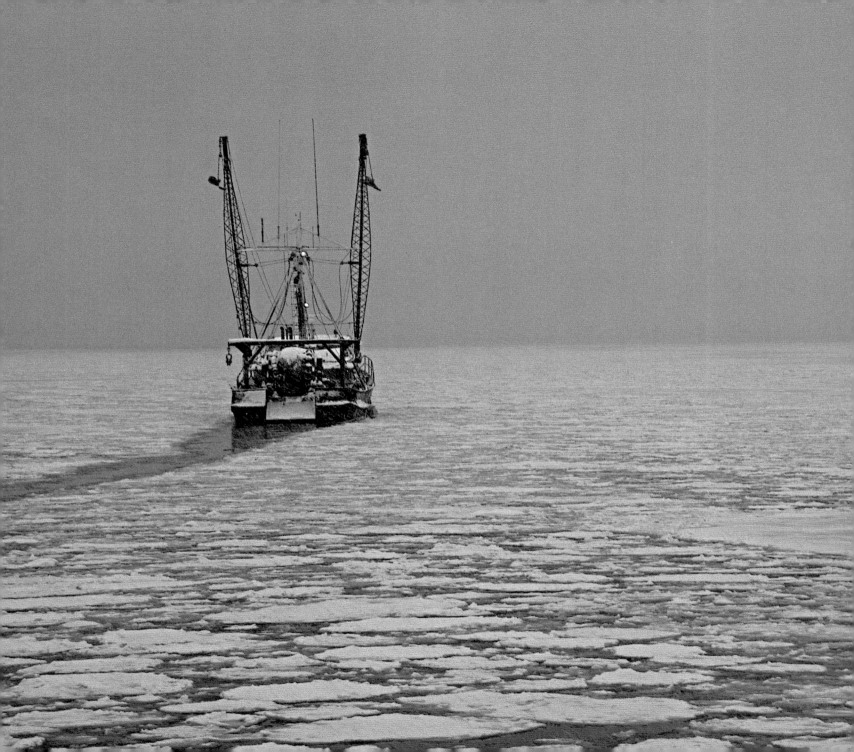

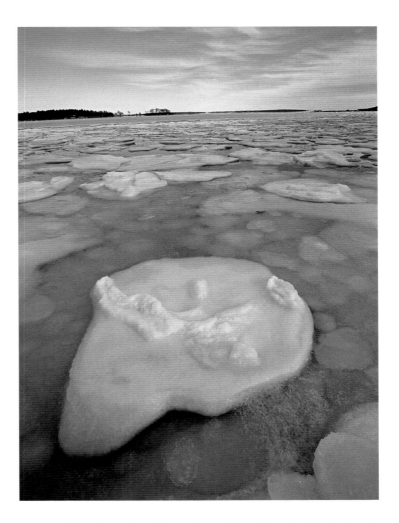

Above: Ice floes from the cold northern Atlantic invade the sheltered mid-coast harbor at Camden.

Left: A fishing trawler heads out to work, navigating light ice in Portland's harbor.

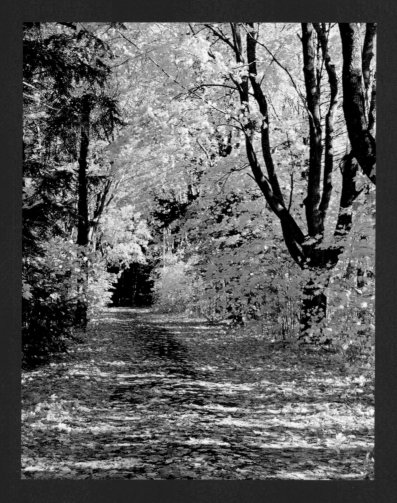

Above: Yellow maples near Falmouth burst into their autumn glory.

Right: The highest point in Maine, Mount Katahdin in Baxter State Park rises to 5,268 feet, marking the end of the 2,174-mile Appalachian Trail that begins at Springer Mountain, Georgia.

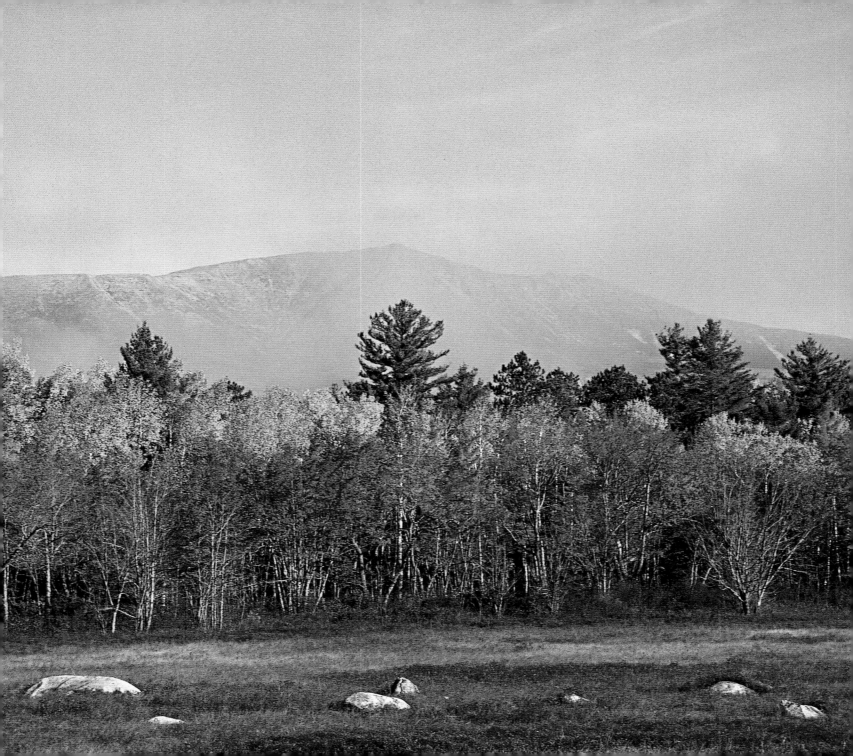

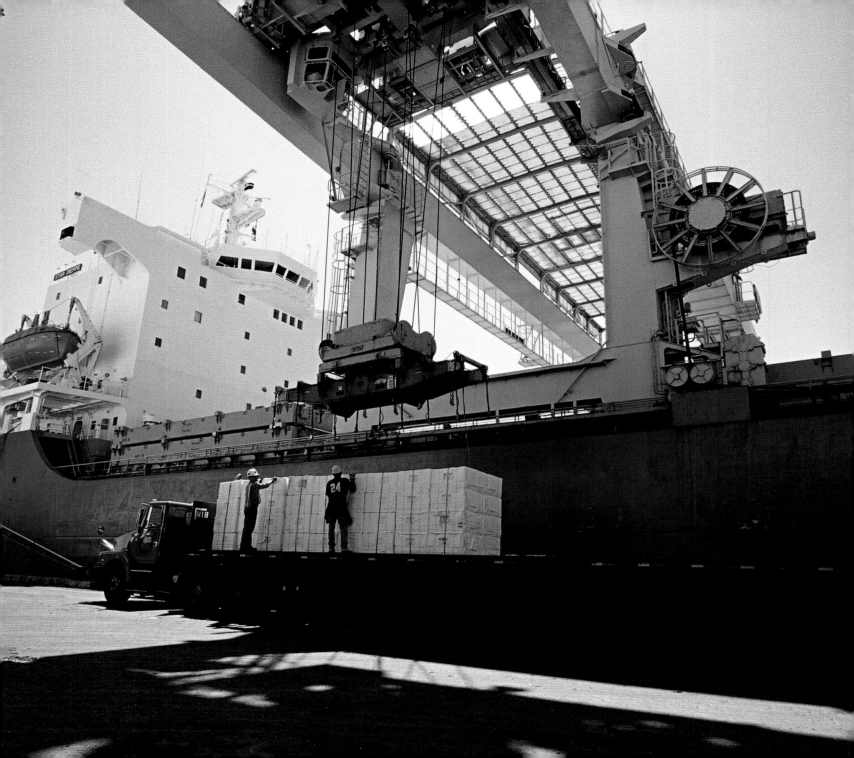

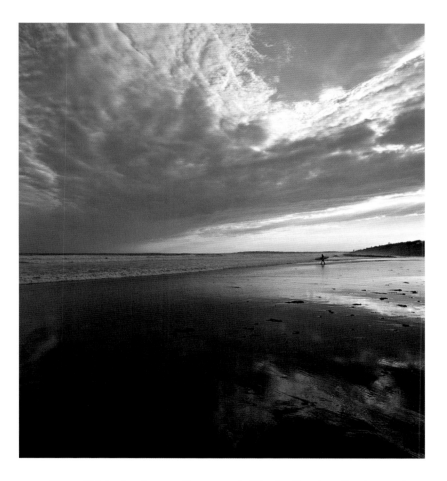

Above: One of Maine's prime surfing spots is Higgins Beach at Scarborough in southern Maine.

Left: Workers at Merrill's Wharf in Portland load lumber onto a container ship for transport.

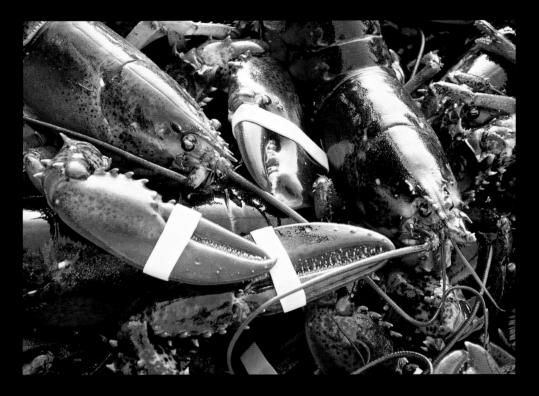

Above: Maine lobstermen bring in more than 50 million pounds of lobster each year.

Right: At the Portland Fish Exchange, the nation's first all-display fresh seafood auction, restaurateurs and processors bid on each day's catch.

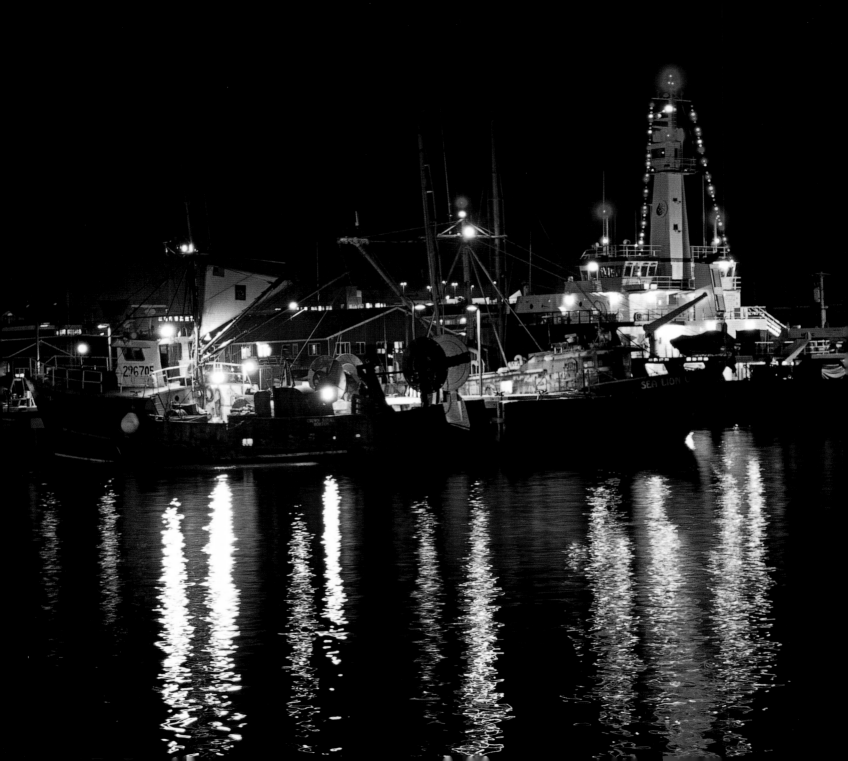

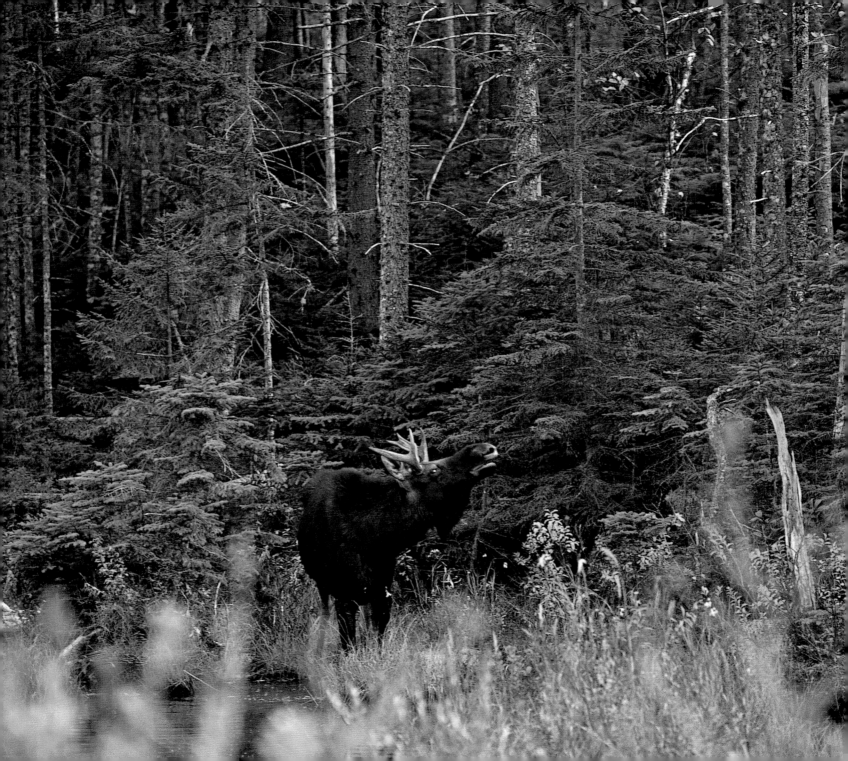

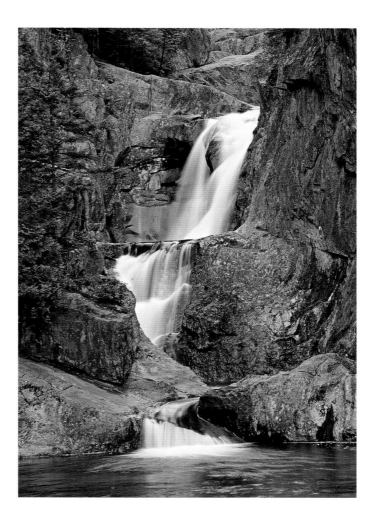

Above: The Sandy River drops through light-brown quartzite in a series of falls and pools known as Smalls Falls, a most enjoyable place to walk or picnic.

Left: A bugling moose sends out his call for a mate—unlike the quiet moose resting under a pine tree that is featured on the Maine state flag. Nearly 30,000 moose wander Maine's wild lands.

PHOTO BY GERRI GAUTHIER

Right: Sugarloaf/USA Ski/Snowboard Resort brings downhill (and cross-country) skiers from near and far to its facilities on 4,237-foot Sugarloaf—Maine's second highest mountain.

Below: Snow-making equipment is called into use at Sunday River Ski Resort at Bethel in western Maine. During the summer, golfers come to enjoy the state's premier course in the valley below.

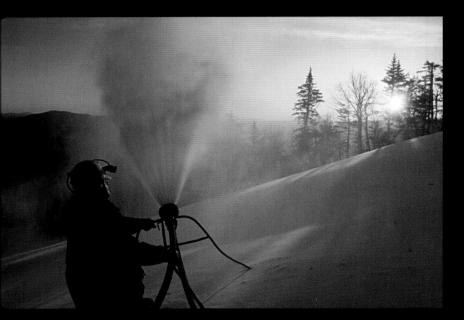

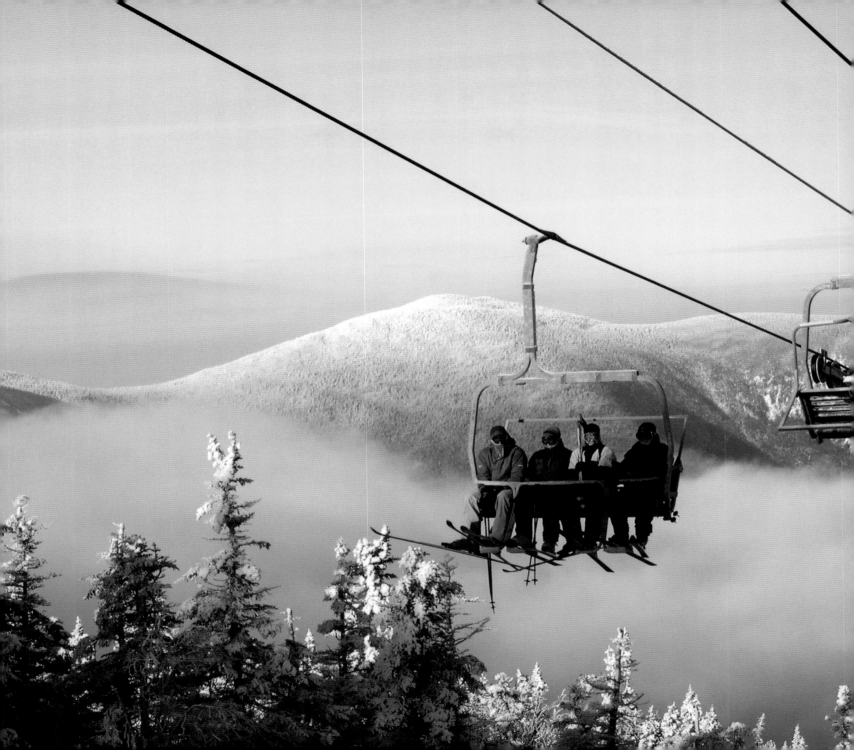

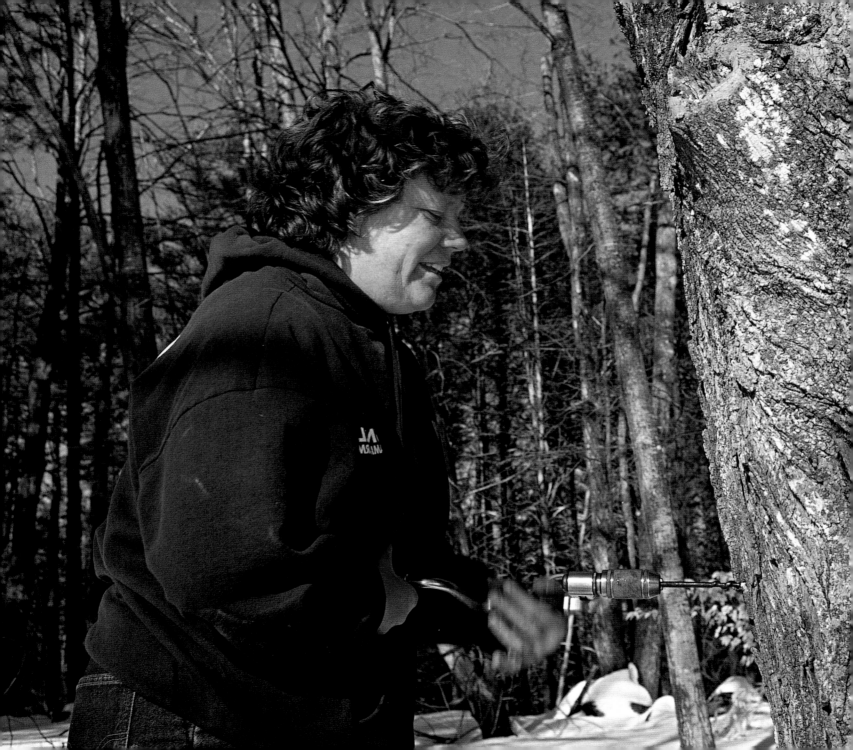

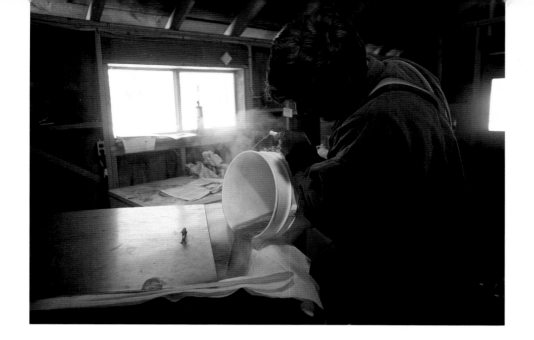

Maple syrup production contributes $6 million to the state's economy. The owners of the Snell farm, in Bar Mills, demonstrate the production process: After trees are drilled and sap collected *(facing page)*, it is poured into steamers *(above)* to be boiled down *(right)* and pasteurized. Almost all of Maine's 300,000 gallons of maple syrup is sold in bulk.

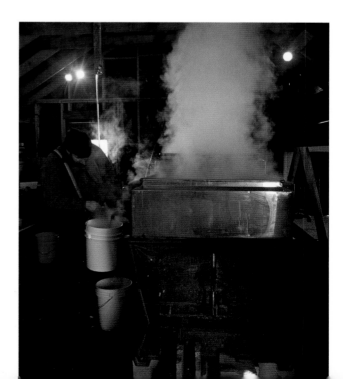

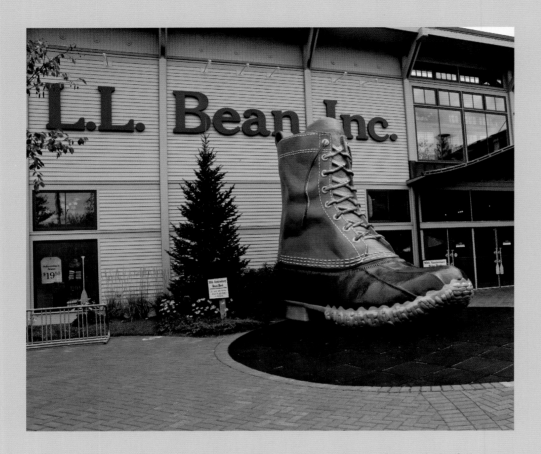

Above: In 1911, Leon Leonwood Bean invented the Maine Hunting Shoe and, the following year, opened his one-man shop in Freeport. Today, the rubber-and-leather boot is honored with its own sculpture outside the company's flagship store.

Right: Morning mist rises from farmland near Cape Elizabeth in southern Maine.

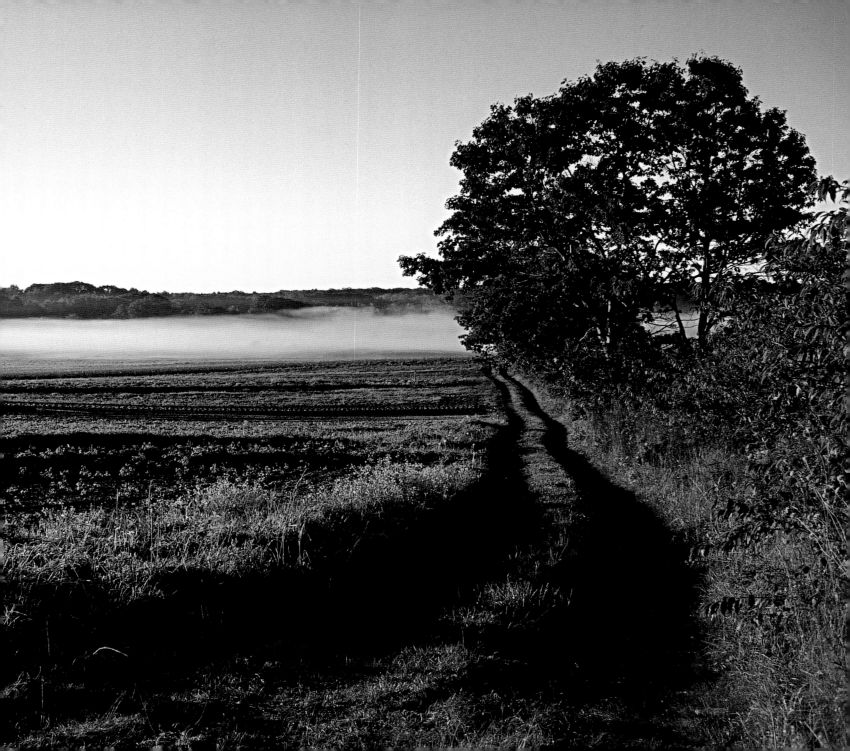

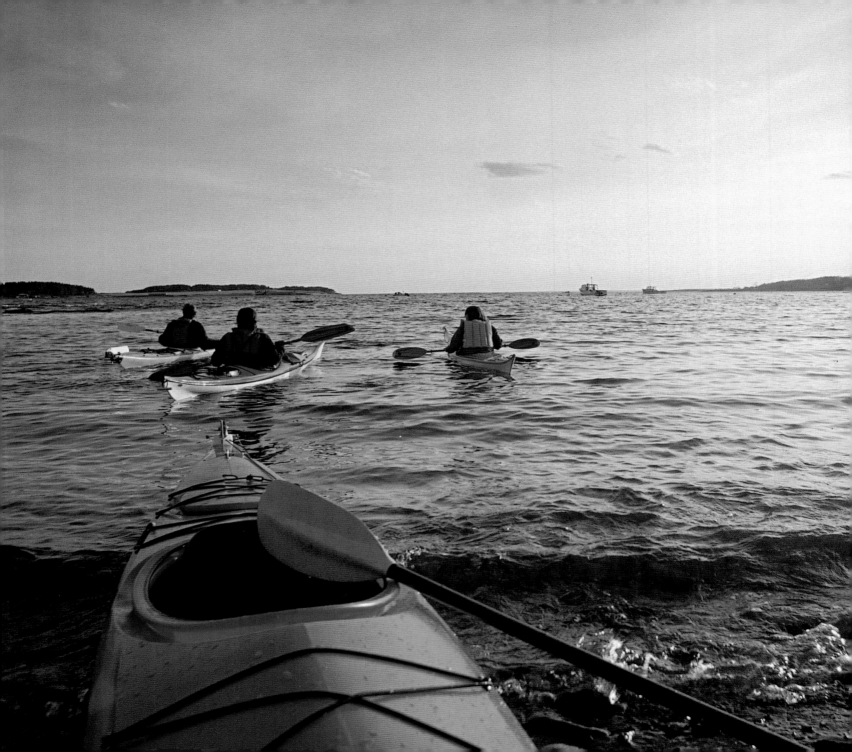

Left: Sea kayakers paddle through Kettle Cove at Cape Elizabeth.

Below: In Harpswell, there will be a clambake tonight. Maine's soft-shell clams burrow into tidal mud for protection, but about $10 million worth of them are dug privately and commercially each year.

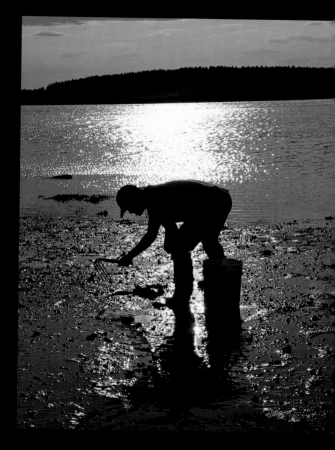

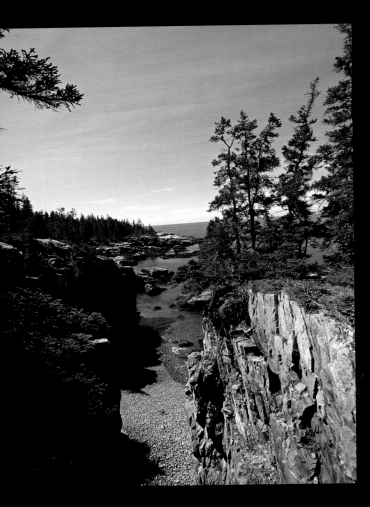

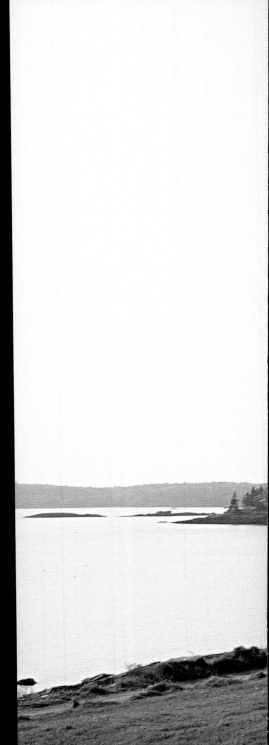

Above: Following the Schoodic Peninsula scenic driving loop rewards visitors with ocean views like this one.

Right: Colonial Pemaquid State Historic Site includes a rebuilt tower of Fort William Henry, modeled on the second of three forts that were constructed at the settlement, which was established in the 1620s. Begun by private proprietors, Pemaquid later was controlled by the colonies of New York, Massachusetts Bay, and the Dominion of New England.

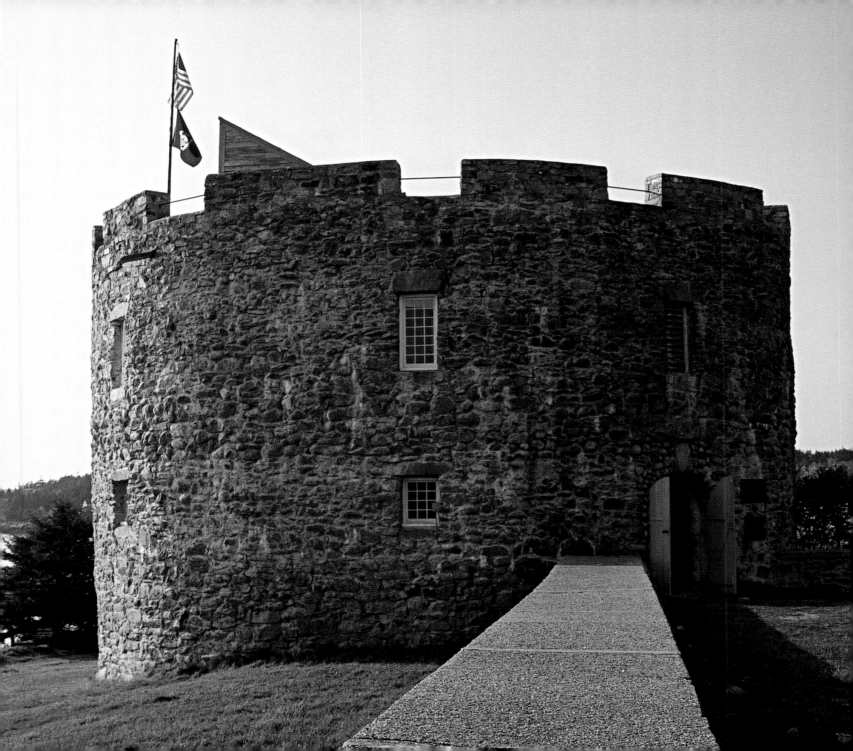

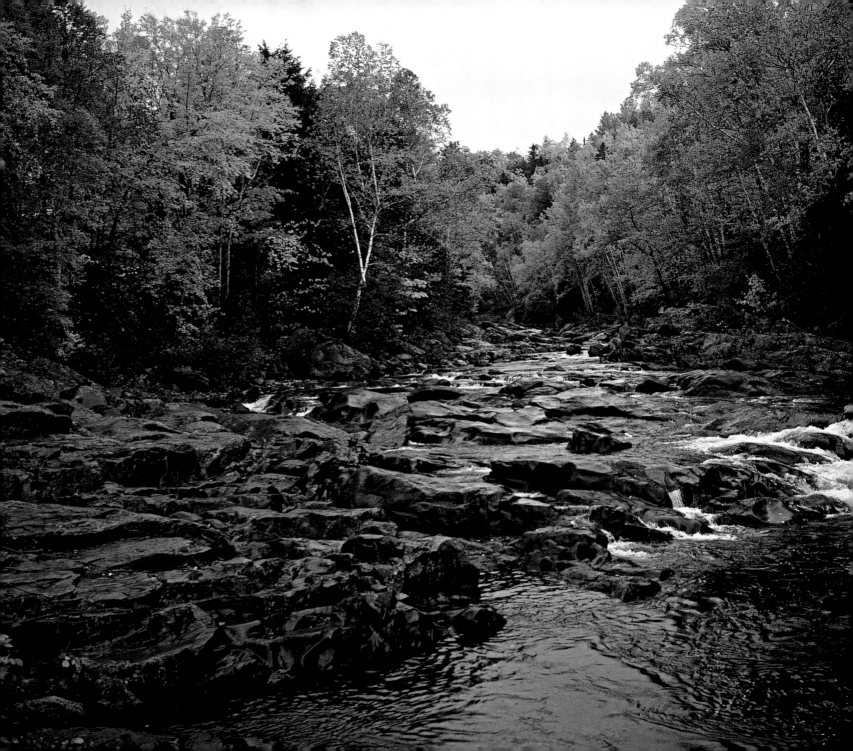

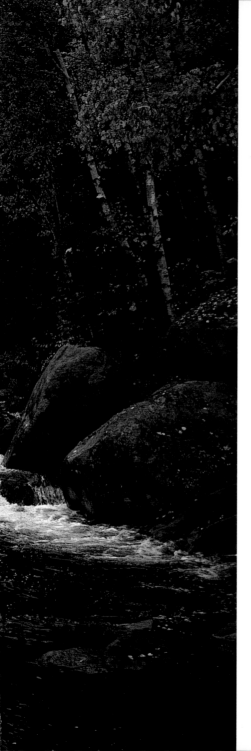

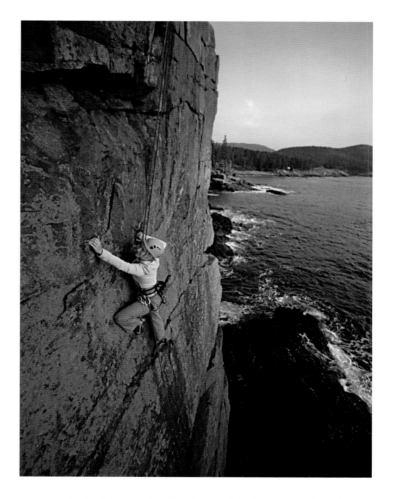

Above: Rock climbing on Acadia National Park's oceanside cliffs, especially Great Head, has boomed in popularity.
PHOTO BY JOSE AZEL / AURORA PHOTOS

Left: The Carrabassett River winds through brilliant fall color near Kingfield and Sugarloaf Mountain in western Maine.

Right: Wheat is one of the lesser crops here, with Maine ranking forty-first among the states in its production.

Below: Potatoes produced on 62,000 acres of fields rank Maine sixth nationally among potato growers.

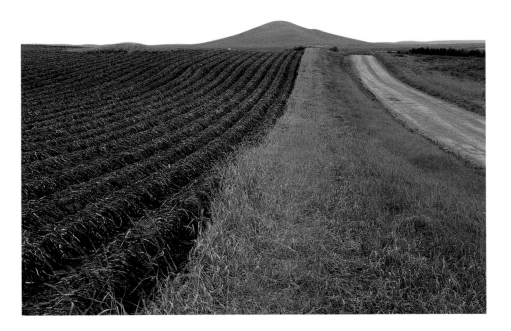

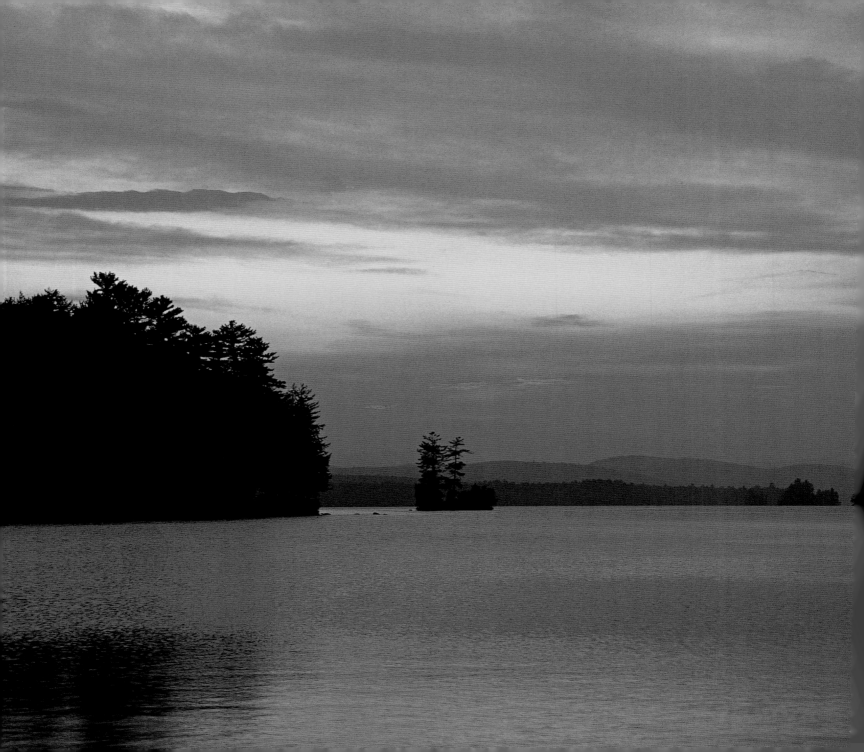

Left: Sunset over Pleasant Pond, Bridgton, portends rainy weather for western Maine. Guided fishing trips are one way to enjoy the area, in addition to canoeing, skiing, and viewing fall color.

Below: The Portland Head Light in Fort Williams Park is Maine's oldest lighthouse, its first light shining over Cape Elizabeth in 1791.

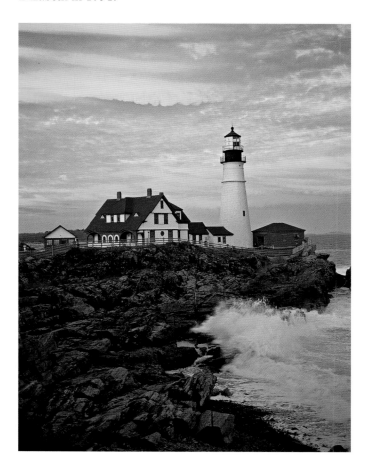

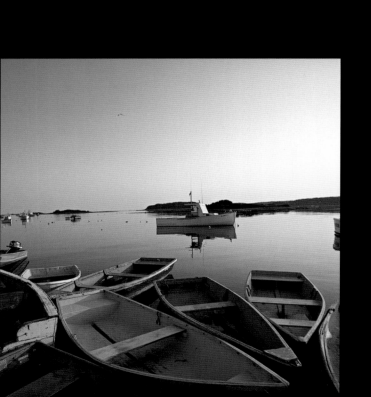

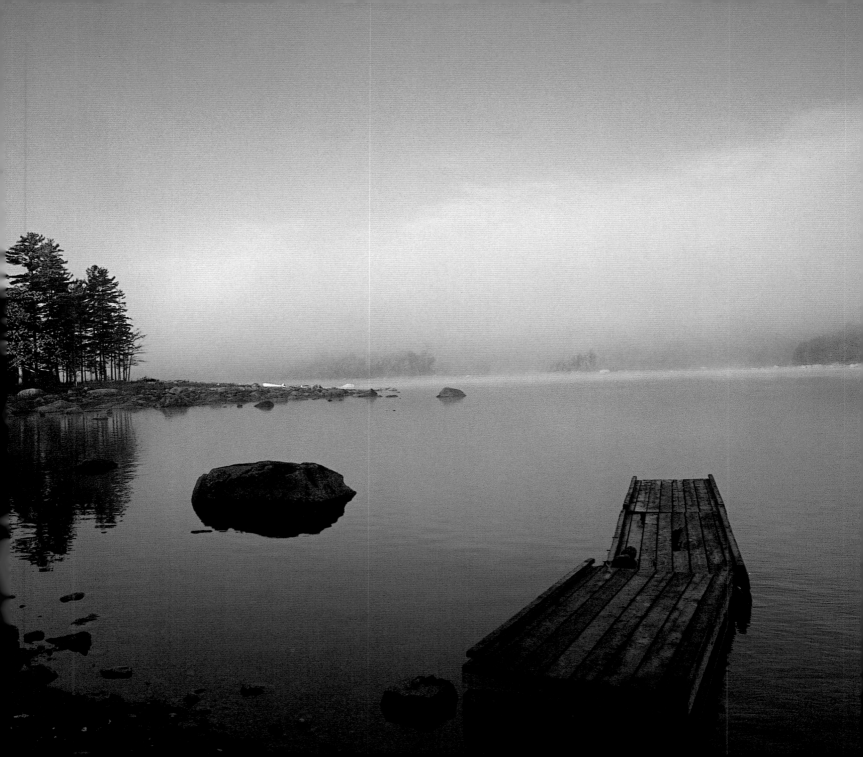

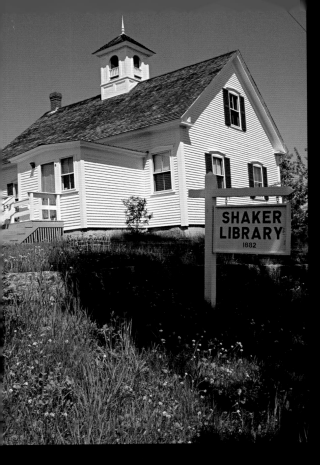

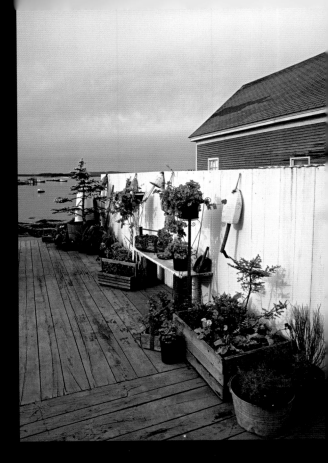

Part of Sabbathday Lake Shaker Community, including museum, is open to visitors during the summer. The

Stonington on Deer Isle in downeast Maine offers historic inns, fine dining, and plenty of locally caught

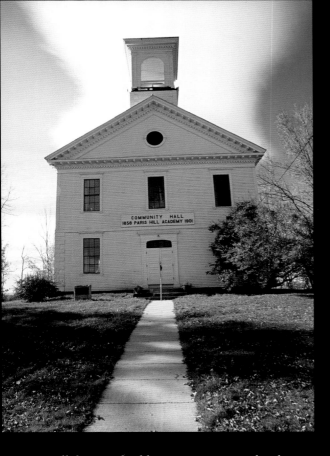

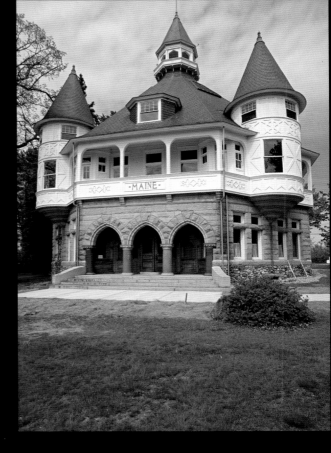

In Paris Hill, historic buildings are repurposed rather than razed, with the nineteenth-century academy becoming the community hall, and the old granite jail now serving as the library.

Built as the Maine pavilion at the World's Columbian Exposition of 1893 in Chicago, the octagonal Maine Museum was dismantled afterward and brought home to Poland Spring on sixteen railroad cars. Exhibits cover the exposition and also the Ricker innkeeping family who purchased and preserved the building.

Right: Reid State Park became the state's first publicly owned saltwater beach in 1946, when businessman Walter E. Reid donated the sandy shoreland near Georgetown.

Below: Starfish, or sea stars, move along the ocean bottom with hundreds of tube feet, feeding on zooplankton by extruding their stomachs to digest the tiny creatures.

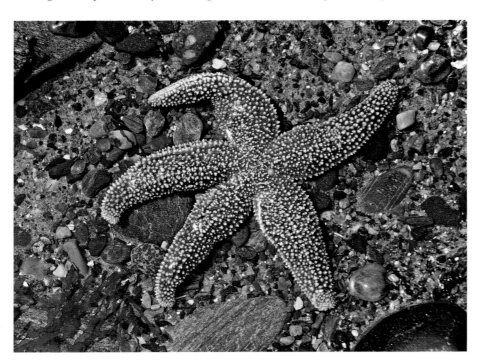

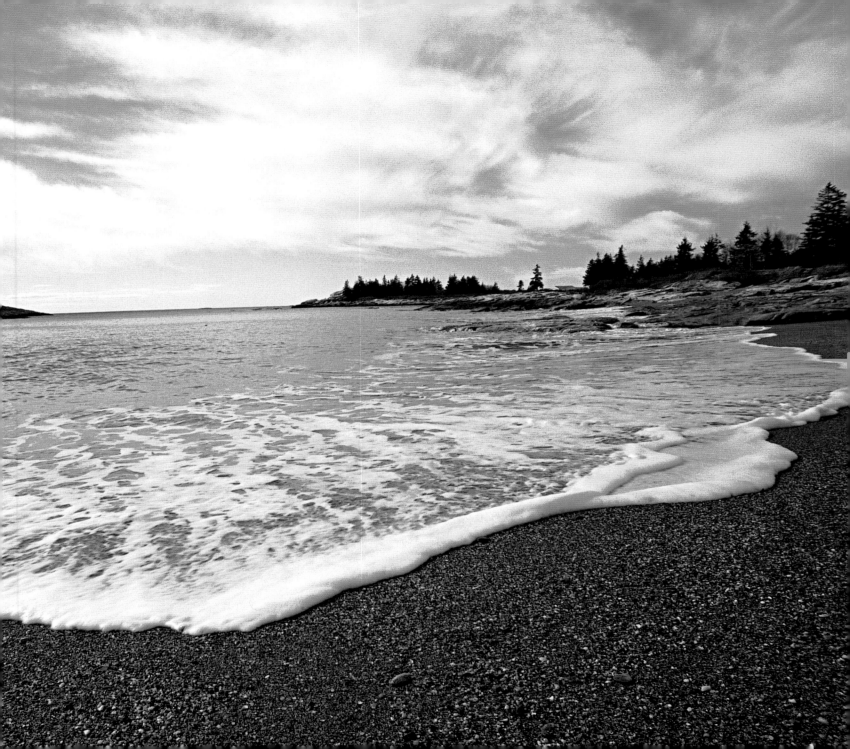

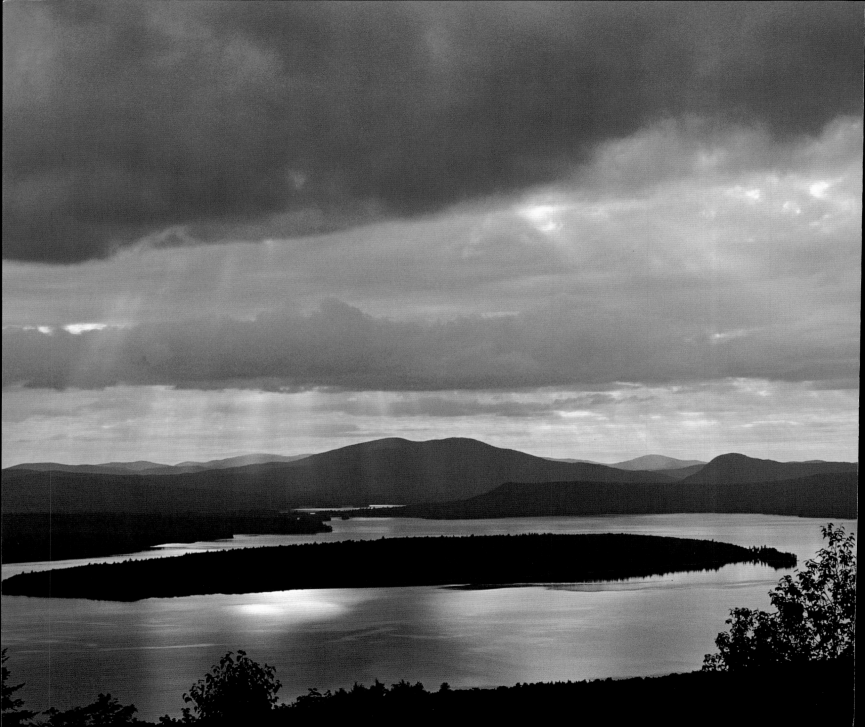

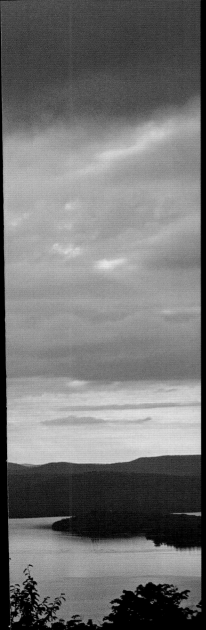

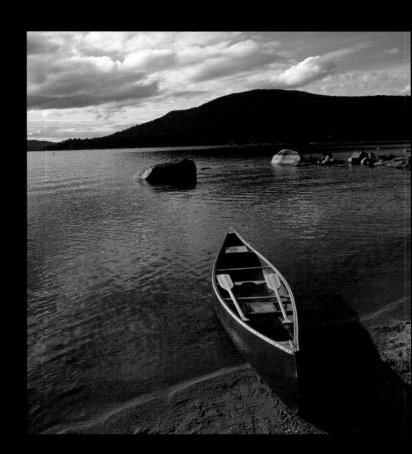

Above: Mount Blue rises above Lake Mooselookmeguntic, a popular place for canoeing and fishing.

Left: One of the most stunning outlooks in the state, Height of Land offers this dazzling view of Lake Mooselookmeguntic and the surrounding mountains.

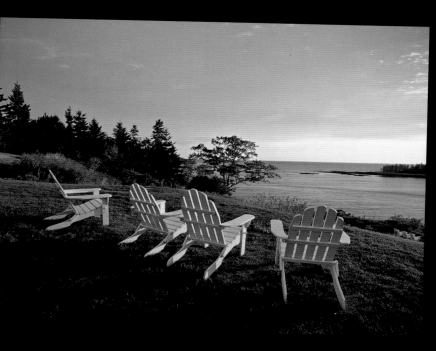

Above: Stop and rest a while on the Island of Georgetown in the Kennebec River, homesteaded in 1650 and incorporated in 1716 as Maine's tenth town.

Right: Sunrise over the sea silhouettes the Portland Head Light.

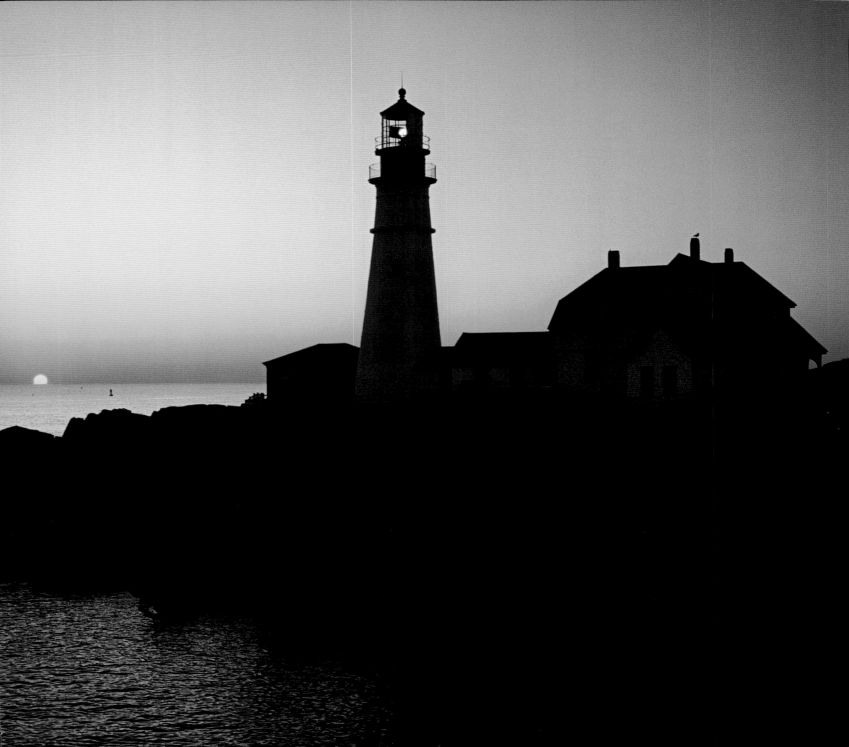

NANCE TRUEWORTHY is a photojournalist who specializes in assignment, stock, and location photography. Her work has been published nationally and internationally in books, magazines, calendars, and greeting cards. Nance is the author of four books, *Maine in Four Seasons, Down the Shore, A Seat on the Shore,* and *A Guide to the Islands of Casco Bay.* Her photographs appear in the book series *America 24/7.* Her work was also featured in a Smithsonian Museum exhibit entitled "Ocean Planet" that traveled throughout the United States.